THE
POLAR
BEAR
IN THE
ZOO

A Speculation

MARTIN ROWE

LANTERN BOOKS • NEW YORK
A Division of Booklight Inc.

2013
Lantern Books
128 Second Place
Brooklyn, NY 11231
www.lanternbooks.com

The author gratefully acknowledges permission to reprint "Anatomy and Dissection Class, Canadian University, 2007"; "Boats Crowd Around the Wild Alligators for a Photo Op"; and "Polar Bear in Captivity at the Toronto Zoo, 2005," by Jo-Anne McArthur © Jo-Anne McArthur Photography; and "Hippopotamus, Washington, D.C., 1997"; "Giraffe, New York, 1997"; and "Lion, Los Angeles, 1998": from *Captive Beauty: Zoo Portraits* by Frank Noelker (Urbana and Chicago, University of Illinois Press, 2004), copyright © Frank Noelker. The photograph of the polar bear in the Toronto Zoo, c. 2013: copyright © Martin Rowe. Unless otherwise indicated, all biblical quotations are from the New Revised Standard Version © 1989, 1995 by the Division of Christian Education of the National Council of the Churches of Christ in the United States of America.

Library of Congress Cataloging-in-Publication Data

Rowe, Martin.
The polar bear in the zoo : a speculation / Martin Rowe.
pages cm
Includes bibliographical references.
ISBN 978-1-59056-391-5 (pbk. : alk. paper) —
ISBN 978-1-59056-389-2 (ebook)
1. Human-animal relationships—Moral and ethical aspects. 2. Human-animal relationships—Psychological aspects. 3. Human-animal relationships—Philosophy. 4. McArthur, Jo-Anne. Polar bear in captivity at the Toronto Zoo, 2005. 5. Photography of animals—Psychological aspects. 6. Animal welfare. 7. Animal rights. I. Title.
HV4708.R687 2013
179'.3—dc23

2013014991

For Gene

Acknowledgments

This book would not have been possible without the extraordinary dedication and compassionate eye of Jo-Anne McArthur and the vision of the other photographers profiled in this book: Frank Noelker, Karen Tweedy-Holmes, James Balog, Tim Flach, and Barry Steven Greff. I'd like to thank director Liz Marshall and the crew of *The Ghosts in Our Machine* for stimulating my thinking about Jo-Anne's photos, and for their remarkable documentary film. My appreciation also extends to Jim Mason for our many years of discussions, which helped clarify some of my ideas, and to Kathryn Chetkovich and Davy Davidson for their support and wise counsel. I wish to acknowledge the skill and thoughtfulness of my editor, Wendy Lee; the geniality and professionalism of my production manager, Kara Davis; and the good humor and considerable emotional intelligence of my co-partner at Lantern, Gene Gollogly. Since 1995, Gene has put up with my occasionally obstreperous and

ill-considered judgments and I value deeply his friendship and candor.

Finally, I want to express my gratitude to Mia MacDonald for being so kind as to introduce me to her world and allow me to live in it with her.

Contents

The Polar Bear in the Zoo is a contribution to Human–Animal Studies (HAS) in general and to Lantern's series of books in HAS in particular, entitled *{bio}graphies*. This series explores the relationships between human and nonhuman animals through scholarship in the humanities, social sciences, and natural sciences viewed through the lens of autobiography and memoir, to deepen and complicate our perspectives on the other beings with whom we share the planet.

Introduction

FOR THE LAST twenty years I've been engaged both professionally and personally with the world of animal activism. I've protested in front of stores that sell fur, circuses that use animals, and labs that conduct invasive tests on them. I've written letters, marched in demonstrations, handed out leaflets, held placards, and attended numerous conferences, talks, and seminars. I co-founded and edited a monthly magazine, *Satya*, with the aim of advancing the causes of vegetarianism, environmentalism, animal advocacy, and social justice—all of which I considered to be intertwined and whose supporters I believed needed to work together if substantial and lasting change was to be brought about. I still hold these convictions. After five years I left the magazine and began a publishing company to produce works on the same subjects, including the one you're reading.

Over the course of these two decades, I've read many books that make the case for the rights of animals, unfurl-

ing arguments situated in political theory, various schools of analytic and continental philosophy, ethic-of-care feminism, environmental studies, and several religious traditions—and, to a greater or lesser extent, all of these works have influenced my views on and thinking about how we might renegotiate our relationship with the other-than-human world. I've also edited and published numerous titles that present the sound environmental, human-health, climate-change, and animal-welfare reasons for adopting a plant-based diet. So voluminous are these several libraries and so well-trodden are the various pathways through the theoretical and practical fields that I see no reason to re-rehearse the arguments here. (A select bibliography of these works can be found at the back of this book.)

It's gratifying for those of us outside the academy to observe disciplines grappling with the tortu(r)ous legacy of our attitudes toward our animal brethren. It's pleasing to see Human–Animal Studies (HAS) gaining widespread approval within the schools of arts and social sciences, as well as the environmental and biological sciences, in universities in North America and beyond. Every week, it seems, those of us who never concurred with Descartes and Malebranche that animals were mere automata are given the opportunity to welcome with frustration and a quiet nod of satisfaction another study that details how a particular species takes pleasure in a richer interior life, possesses a more extraordinary sen-

sory apparatus, and forms more sophisticated societies than we'd previously imagined.

Within these contexts, however, squats the ugly reality that in spite of our visits to the zoo or travels on safari or our comforting relationships with our pets, many of us interact most intimately with animals when we sit down to eat them. And in spite of the insights we're gaining into the exterior and interior worlds of other creatures, the vast majority of us are failing to handle conceptually the numbers involved and the methods utilized to obliterate domesticated and wild beings: billions upon billions of animals slaughtered; acre upon acre of habitat decimated; the most extensive background extinction rate of fauna since the Ice Age.

Given the above, and because others have made the case more comprehensively, elegantly, and perhaps more even-temperedly, *The Polar Bear in the Zoo* is not a survey of current thinking about animals or animal advocacy, or an argument as to why you should support animal rights or go vegan. Nor is it a dispassionate analysis of the way we treat or look at animals. Furthermore, although it takes as its subject a photograph of an animal in a zoo, this monograph is not an analysis of photography (*à la* Susan Sontag or Roland Barthes) or a direct critique of zoos. Instead, the work is at once a *cri de coeur* and a snapshot, a squint through the viewfinder, a glimpse of what is seen and speculation of what remains unseen between the blinks and clicks of the shutter.

I take as my inspiration the writer and half-hearted vegetarian Elizabeth Costello, who is an insistent presence in the works of the South African–born novelist J. M. Coetzee. Although Costello stubbornly retains her fictional existence within Coetzee's writings, I nevertheless like to believe she shares my feeling that, for all their finely tuned and robustly made arguments or their dense and elliptical deconstructions, the Western philosophical traditions still haven't articulated an adequate critical response or gathered a sufficient sociopolitical resistance to our mistreatment of nonhuman animals.

By way of an (admittedly unsatisfactory) counter-weight, Costello herself presents in *The Lives of Animals* her clear-eyed, if bleak depictions of our perverse and shameful humiliations, observations striated with the ironies that marble Costello and the colleagues whom she insults or berates. That a character as unrelenting and annoying as Elizabeth Costello should keep turning up in Coetzee's fiction is a reminder of how hard it can be for a writer to escape from his own embarrassing and unclubbable *personae*, no matter how well-intentioned or commanding of the moral bluffs and narrative heights he may be. No writer can free himself from the disgrace that stains our being human or can avoid the unwelcome objections of his closest readers.

One attribute that's relatively free of Coetzee's irony is Costello's tiredness. Like me, she's tired of our complic-

ity; of our failure creatively and intellectually to penetrate the mysteries of our offhand or systematic cruelties; of the endless self-serving narratives and circumlocutions to which we're subject and to which we subject others about what behavior we deem suitable to which suitable animals. Costello doesn't spare either herself or others from her prickly insertions: she knows her presence is egregious, that we tolerate her because we'd prefer to rub along rather than face our bad faith, and that we listen on sufferance because we once admired what she had to say. To quote the poet Elizabeth Jennings: "I think I understand a mood like that."

Like Costello, I continue to hold a few flickering candles for the arts, which for all their guttering insufficiencies can still throw into relief our own blind spots and reveal apertures through which we may glimpse other possibilities. I'm also drawn to the tropes and *mythoi* found in religious texts, particularly for their capacity to surprise us and shock our sensibilities out of complacency. That said, *The Polar Bear in the Zoo* is not a conventionally theological work, either. Instead, it works retro- and prospectively, looking for the moments *before* and *after* the revelation. As Coetzee writes, responding pointedly to the linear argumentation of the *penseurs* gathered in Paola Cavalieri's volume *The Death of the Animal*, for people such as us "there took place something like a conversion experience, which, being edu-

cated people who place a premium on rationality, we
then proceeded to seek backing for in the writings of
thinkers and philosophers" (89).

One can, of course, dismiss Elizabeth Costello's
jaundiced vision as only the *aporia* of old age: the puz-
zlements and fears, the loss of friends and depletion of
energy, the arrival at the inevitable impasse of death.
I'm sure I could also be accused of writing from the
disappointments and re-evaluations of my middle years,
with the self-indulgent, even self-regarding pessimism
that one hadn't made the impact on the world to which
one thought one was entitled. Perhaps things *will* change
for the better; that generations to come will be aston-
ished that we treated animals so maliciously; that they'll
be mortified at how wholly we exerted our absolute
authority over their lives and how little we questioned
our ignorance. We can but hope.

I also appreciate that, for some, the saving of an indi-
vidual animal's life—in the manner of Loren Eiseley's
much-adapted story of the starfish on the shore—pro-
vides a minimum level of solace (not least to the animal
in question) amid so much unattended or ill-attended
mortality. I've known several people who found that
simply being in the presence of, or caring for, an animal
was enough to reveal that creature's personality and indi-
viduality and awaken the conscience about those animals
beyond our immediate domain. For some of these indi-
viduals, including the late Henry Spira, who became an

advocate because he could no more imagine inflicting pain on another being than eating his beloved cat, the decision to become an animal activist was simple. Case closed; argument solved; get organized.

Such directness can be refreshing. I once went to a conference in which various scholars, scientists, and philosophers were discussing which animal felt what, and to what degree that conferred what kind of moral considerability on our and their behalf. Spira, as irritating a gadfly as Elizabeth Costello (although better-humored), rose to his feet, denounced the debate as so much "Talmudic babble," and walked out. No doubt he would have considered what follows here to be indulgent maundering, given how manifestly animals suffer at our hands, how self-evident are their personalities, and how much work remains to be done. But as I hope *The Polar Bear in the Zoo* shows, it's sometimes hard to see what or who is in front of one's face, and that for all the obviousness and demonstrability we'd like to assign to the "Other" who appears before us, it's sometimes much easier to ignore that reflection and move on.

Frame

A FRAME STRUCTURES a body or an object. Although essential for the assemblage and maintenance of a shape, once the frame is covered over, it's forgotten. A frame delimits space; it defines and confines the object it contains and retains. The frame heightens and brings to our attention; it keeps out what complicates our vision. Observed and overlooked, essential and peripheral, the frame marks a border between the real and the imagined.

Sometimes the frame is itself framed: the actor beneath the proscenium arch or upon the thrust stage addresses the audience directly; the skeleton of a building is, like the Centre de Georges Pompidou in Paris, turned inside out; the painting retreats, a *trompe-l'œil*, into the building it decorates. For each inversion or recursion of the artificial and real, however, the discriminating eye

adjusts and reasserts the frame. The eye, our organ of predation, scans the horizon, picking out those we might take or who might take us. We may distract, redirect, and trick the eye, but we cannot halt it from allowing us to judge what it sees.

This book is a reflection on frames and perspectives: of a life, an image, and an enclosure. The title comes from a photograph by Canadian photojournalist Jo-Anne McArthur called "Polar Bear in Captivity at the Toronto Zoo, 2005." The shot is one of an ever-expanding series entitled We Animals, which consists of McArthur's depictions of animals in zoos, laboratories, circuses, rodeos, factory farms, and other places where they're utilized by human beings for our entertainment, research, or food; and some of the people and places that care for those abandoned or left behind.

The Polar Bear in the Zoo attempts two things: to examine this compelling photograph and raise some questions about what or who it is we see when we come face to face with the animal; and to expose the contradictions that continue to confront me after twenty years as an animal advocate and vegan. These are two different aspects of the same mirror. Since a reflection throws back an impression—both distorted *and* revelatory—of what materializes within a frame, it's necessarily a projection of the viewer. None of us is a blank slate in responding to the animal world; none of us is free to renounce our being human; none of us can slough off our subjectivity.

So, because the "I" is always structuring what the eye believes it sees through the lens, the first and last frame must be my own.

* * *

I first awoke to the terrible conditions for the animals we exploit over a quarter of a century ago through the influence of my partner, Mia, who'd been a passionate advocate for animal welfare and rights since she was a young girl. I wasn't completely unaware of animal life. I spent part of my childhood next to a farm. I loved my cats and petted dogs. Our family visited safari parks and zoos near our home. I liked reading adventure stories that involved animals, but, unlike Mia, I didn't think much about their welfare.

I had some idea of where food came from, beyond the tin cans and cellophane wraps and polystyrene packages found in a supermarket. My parents grew a wide variety of herbs and vegetables in the gardens we cultivated when I was growing up in England in the 1970s and 1980s. We composted and collected rainwater, maintained a greenhouse, froze soups over the winter, and ate whole foods on a daily basis. In the fall, I'd dig up the potatoes and carrots, pod the peas, pull the runner beans, and pluck the tomatoes. On Saturday mornings, my father would take my brother and me to the local butcher to choose the cuts of meat he wanted, which

more often than not were sliced from a body in front of our eyes. In spite of such a visceral exposure, I never considered whether the taste or pleasure or habit of consuming animals' bodies was worth the death of those creatures whom I'd never have harmed myself.

It was only after I arrived in the U.S. that I became an activist. Mia took me to talks about and rallies against the cutting up of animals for fur and vivisection. I'd known some people independently of Mia who were self-professed vegetarians. They seemed in good health and to live a full life, and it might, I thought, be an interesting experiment to try the diet to see what happened. In 1989, I began to call myself a vegetarian, although (worried in my deeply conventional way about whether I was getting enough protein) I continued to eat fish and lobster. Several months later, I stopped eating all animals. Two years after that, in 1993, I moved in with Mia and we decided to give up milk, eggs, cheese, and butter.

Among vegans, mine is a somewhat unusual conversion narrative. I wasn't disgusted by animal flesh: to this day I remember fondly the taste and smell of honey-roasted ham, crispy bacon, and Brie and Stilton cheeses. I wasn't overweight or undergoing the kind of health problems that might encourage a change of diet. Unlike some advocates, I hadn't felt a gut connection between the meat I ate and a beloved nonhuman companion. I wasn't exposed to extensive, horrific footage of animals under duress; I didn't equate their suffering with

that of my own species. I wasn't cast out from my family or society because of my new views. I hadn't read widely about animal rights and hadn't engaged in long conversations with those who could persuade me of the case. I couldn't even summon up much animus toward the individuals who exploited these animals for our putative benefit.

If I could detect an emotion behind my choice, it was the *routineness* of the violence to which the animals were subject, the everyday psychological and physical deprivations embedded within the elaborate degradations of a mechanized system of metal restraints, wire-mesh cages, and stereotaxic devices in laboratories and factory farms. To my mind, it wasn't as if these animals' needs were particularly complex. They wanted to turn around, flap their wings, and dust-bathe; to bask in sunlight and breathe fresh air; to root and graze and nest and play. They wished to be with others of their own species and form families. They hoped to avoid pain and isolation. To satisfy these desires, I thought, surely wasn't too much of a burden, given how much we asked of them. Yet everywhere (it seemed) people were busily working on our behalf to deny them these elementary freedoms, even as they were pushing the animals harder to deliver whatever it was we expected from them.

The excuses that were offered in defense of our continual closing off of options for nonhuman animals— that they don't suffer; that we're doing it for their own

good; that we need to eat, to be clothed, to conquer disease—only begged the question: It was one thing to corral these creatures for our gain, but why did we have to humiliate them, grind them under our boot or yank them by the neck, dress them in silly costumes and make them perform stupid tricks? What had they done to us to deserve such vilification or ridicule? What was it about them that made us behave so vindictively?

A sociologist might pinpoint other reasons for my decision to become a vegan and an activist other than my conscious response to what I was learning about how animals were treated. Animal activism was hardly foreign to me, although I hadn't paid much attention to it up to that point. Then, as today, Anglophone writers, activists, and thinkers were well represented among its leading lights. One might even say that the two-hundred-year-old animal advocacy movement was typically British, stocked with vicars, aristocrats, bluestockings, dissenters, and the occasional working-class hero. Even the *topos* of animal activists as eccentric spinsters or oddball loners (a stereotype that Costello approximates) slotted comfortably into a certain kind of (culturally) English person: an enthusiast for unrespectable pursuits, a curmudgeonly misanthropist, and an unmannerly meddler in other people's business.

A psychologist might note that I wanted to ingratiate myself with Mia, and vegetarianism seemed a cause dear to her heart. I already considered myself an environmen-

talist and was an avid recycler: the commitment not to eat animals seemed similarly conservationist, even though at that time few of us had any idea about how destructive intensive animal agriculture is on the land, water, and air. (Or, for that matter, how, according to *Livestock's Long Shadow*, published by the Food and Agriculture Organization of the United Nations, it contributes almost twenty percent of global greenhouse gas emissions.)

I'd become skeptical of the upper-middle-class norms of my upbringing and open to subaltern views of history, science, gender, politics, and our attitude to Nature. So it was easy to integrate my left-leaning ideas into those propounded by the movement's elites and its various Jacobins, even though some of the grassroots members with whom I protested hadn't yet received the memo that animal advocacy was to be placed along the continuum of struggles for gay rights, women's rights, and environmental and social justice.

Any inconvenience within the broader culture I might have undergone from being in such a niche was offset by the focus and representational enlargement the narrower social frames provided me with. In the mid-1990s, to call oneself a "vegan animal advocate" was to identify with an extremely select sub-group, which I'm sure lacquered me with the contradictory gloss of victimization *and* self-importance—a potent combination for a privately educated, heterosexual WASP such as I. Like members of a revolutionary cell or religious cult,

my fellow initiates and I elevated ourselves into a realm of purity into which few could gain access. Because we *knew*, we were able to see a world soiled by the horrors of capitalism and exploitation in a manner and to an extent that others had yet to be made aware of.

It's hard for me to detect from a distance of twenty years to what extent any or all of these motivations underlay my ostensibly moral decision to become an animal advocate. What I do remember is that I acted the same as virtually everyone else when they've seen the light: I communicated my beliefs to others in every way I knew how. I determined that if people only realized what animals underwent every second of every day they'd be outraged and would want it to stop. If they could only *see* what was self-evidently there—the gassed or anally electrocuted minks screaming within the fur coat; the hooks, chains, and whips behind the dancing elephant; the chimpanzee held in isolation for seventeen years and obliged to undergo Hepatitis C experiments, and so on—they'd not only no longer want to be part of that oppressive structure but would join us to shut it down.

I'm sure that at the beginning, like all new zealots, I was, to put it mildly, a pain in the ass, even if an energetic one. I used a lot of the rhetoric you read in the paragraph above. I wore my heart on my sleeve and my badges on my lapels. No doubt I was overcompensating for all those years I'd been blithely oblivious to the misery

nonhuman animals endured to supply my food, cloth-
ing, medicines, and entertainment. I was also probably
attempting to show how comfortable I was with the rites
of passage and the dialect of the tribe into which I'd just
been inducted. I conveniently forgot that insufferable
self-righteousness rarely persuades anyone of your point
of view and that few people want to join a movement
if scolding high-handedness seems to be the unofficial
prerequisite of membership.

As I doubled down on what I've heard referred to,
inadequately, as "the vegan lifestyle," I was aware that
any investigation of my belief system would reveal it to
be full of inconsistencies and contradictions, if not total
incoherence. Because some ten *billion* land animals (and
several billion more marine creatures) are killed each
year for food in the U.S., my veganism was essentially
symbolic. I didn't *directly* save any animal's life, since I
was removing myself from a system rather than rescuing
a creature from death. Indeed, "removing" itself was an
aspiration rather than a fact, since I benefited in many
ways from the exploitation of animals. Parts of their
bodies were likely to have been tested on or contained
in (among other things) the medicines I took. They'd
been ground up into the tarmac I drove on, the glue that
bound the books I read and published, and the food I
fed my cats as a child. I couldn't calculate the numbers
of insects I'd crushed inadvertently or on purpose, or
the mice and other creatures who were swept up by the

combines that harvested the grains I ate, or the other animals whose habitat I'd destroyed in the course of living in the world. Veganism, I would have agreed even then, was a goal rather than a state of being. None of us was pure or perfect and none of us had any reason to be smug—no matter how exquisite we might find the agony of being both correct and misunderstood!

Nonetheless, I found it comforting to convince myself that my avoidance of animal flesh, milk, eggs, cheese, butter, and wool or leather infinitesimally reduced demand for these products and, therefore, in a very roundabout manner, caused one less animal to be born into a wretchedly curtailed life in a concentrated animal feeding operation (CAFO). I thought of my actions as one less male chick thrown into a wood chipper or stuffed alive into a bag to suffocate because he couldn't ovulate. I imagined one less veal calf removed from his mother to spend the entire sixteen weeks of his life undernourished and confined in a cage. I pictured one less sow forced to breed litter after litter of piglets, squeezed into a tiny stall until she was "spent" and sent to slaughter. I even tried to bring to mind one less fish scooped out of the ocean as feed for another fish on an aquaculture farm, one less cow buckling after a bolt to the brain, one less lobster boiled alive.

Like many advocates, I discovered soon enough that, in spite of these stirring and precise horrors, which I enumerated for people *ad nauseam*, others weren't out-

raged by systemic violence toward animals, or at least not enough to question their habits or change their ways. As my fellow activists and I stood outside the fur store or Ringling Bros. Circus with our banners or handing out leaflets, we'd often be subjected to invective about how we weren't doing enough for humans, whether *in* or *ex utero*. Some made it clear that they thought the attention we paid to the welfare of nonhuman animals was the grotesque indulgence of pampered pet-fanciers and people-haters; that it was an insult to consider their plight before that of *homo sapiens*; and that animals should take up their appropriate position at the rear of the seemingly endless parade of sorrow and violence that follows the ever-spinning baton of human folly.

Folks pointed out that animals killed other animals and survival in the wild could be tenuous and short. They reminded us that some farm animals, all of whose lives we begin and end, benefit (however briefly) from shelter, food, medical care, and safety; some trainers bond with their nonhuman performers; cats and dogs exist parasitically off of us to such an extent that it's hard to say who exploits whom. Any worries we may have had about animal welfare, these observers occasionally added, were luxuries we could afford because we, the fortunate citizens of developed countries, no longer had to worry about our own shelter, food, medical care, and safety, or to rear and slaughter our food sources ourselves. Our misplaced distress over these animals' welfare

was a romantic throwback or idealized dream that bore little resemblance to the harsh realities that had always attended the farming life.

A portion of the animosity that greeted our activism was no doubt justified: their arguments weren't unreasonable, and some of us were obnoxious and hostile—manifestations, I've come to believe, of a frustrated impotence or inability to communicate effectively as well as of our own wounded smugness. Looking back, I'd like to believe that, at our best moments, we were taking a stand and trying to educate people as much as we were shriving our own souls. No doubt some of the negative reaction was a function of people responding to their own discomfort at being asked to consider something they didn't want to think about, let alone act upon. Whatever the cause, when the fur store closed, we claimed a victory and moved on, even though we had no evidence that we were the cause of its demise.

◦ ◦ ◦

I wasn't present at the large marches and rallies of the 1980s, being otherwise unaware of their existence. By the time I became active, advocacy on behalf of animal liberation and vegetarianism had infiltrated the mainstream, which meant in part that ordinary people and industries had begun to formulate more sophisticated rejections of or at least pithier responses to our argu-

ments. The movement as a whole had started to redirect its energies away from vivisection, fur-farming, hunting, and the exploitation of animals in entertainment toward animals used for food—for which nine out of ten of the creatures we utilize suffer and die.

Over the years, progress has been made: celebrity vegans promote their cookbooks and get their photos taken at the charity galas; meat and dairy analogues sit comfortably on the shelves of supermarkets throughout the country; ballot initiatives in the U.S. are outlawing some aspects of factory farming; and more products exist that cater to those who don't want their cleaning or beauty supplies tested on animals. Yet, as is often the nature of social change, that progress has not been uniform. For instance, while innumerable options now exist to satisfy vegans' apparently inexhaustible appetite for dessert, laws in the United States criminalize the filming and dissemination of footage taken inside factory farms and, indeed, any facility that uses animals. In March 2013, I found myself outside Ringling Bros. Circus at the Barclays Center in Brooklyn, holding up a sign against the exploitation of elephants and wondering where twenty years had gone.

Some people have responded to the harm that intensive meat production causes to the environment and the wretched conditions in which animals are raised by eating meat and dairy products from animals they believe to have been raised humanely, although what is labeled

or called "humane" is frequently nothing of the sort. I'm as susceptible as anyone to the pastoral idyll of meadows dotted with sheep and barnyards where apple-cheeked dairymaids milk Bessie by hand—in its own way as idealized a vision as the vegan *eschaton*, where, as Isaiah 65:25 puts it, "the wolf and the lamb shall feed together, and the lion shall eat straw like the bullock; and dust shall be the serpent's meat. They shall not hurt nor destroy in all my holy mountain" (KJV).

But the curtains have been lowered on these scenes, if they ever existed, as the vast scale and ubiquitous mechanization of CAFOs have driven small family farms from the economic as well as actual landscape. Although we might yearn for the revivification of Old MacDonald instead of the sponsorship of ol' McDonald's, for "humane" animal foods to be delivered at the same volume that Americans have come to expect would either necessitate every available acre of land to be grazed or meat and dairy to become much more expensive. Even hunting for one's own animal food would still require many more of us to go vegan so that conscientious omnivores can maintain their diet. And the animal would still have to die at our hand.

I've made many accommodations in my comfortable middle age. For one thing, I'm less annoying or in-your-face an advocate now . . . or so I'd like to believe. Avoiding factory-farmed meat and dairy products in favor of "humane" alternatives is exactly the kind of moderate

response that I might have assumed I'd have (d)evolved toward twenty years ago, given my initial lack of a connection with animals. In those circumstances, it might have been *reasonable*, even prudent, from the outset to separate the wild from the domesticated, the species from the individual, and the "scientific" and "ecological" from the "advocative" and the "moral," and not have insisted that the animals we eat be placed upon the same ethical continuum as those we don't.

Yet I remain committed to veganism and the cause of animal rights. The question is *why*? Why so *extreme* or *absolute* a response: that I'd go out of my way to avoid eating animal products, even though a bit of butter here or a lamb chop there or a pair of leather shoes would have little to no impact at all on the survival or otherwise of the bio-pharmacological industrial complex that is contemporary agribusiness? Why continue on this path when vegans remain a tiny minority of vegetarians, themselves a minuscule portion of the omnivorous population? (I mean vegans by choice, since many people around the world eat few or no animal products because they cannot afford them, or the animals they keep are more valuable to them alive than dead.) If our arguments are so persuasive, then why do others find it so hard to stop eating animals and remain willing participants in their affliction?

Goodness knows: it's not because we vegans are smarter, gentler, more thoughtful, or more educated than

other people or civilizations—even though we may like to believe we're in a special class. Highly intelligent, kind, and far-sighted individuals who are deeply committed to reducing suffering in the world continue to justify the consumption of the grossly inflated liver of ducks and geese using the grandiloquent language of culture, taste, or homeland, or simply because it's all they've ever known. But why blame them? I considered myself the epitome of *menschlichkeit* when I ate ox tongue and pigs' liver. If I was so clever, so *sensitive*, so attuned to the nature of things, then why did it take me so long to ask *myself* these questions?

Our psychologist and sociologist friends might suggest that one reason for sticking to this regimen is that it continues to provide me with a social and even ethical cachet, one enhanced by the fact that I've been doing it for so long. It's *merely*, they might note, one among innumerable lifestyle choices that hearken back to a mythical diet from which we departed—one we imagine could allow us to stave off death for a few more years, if we'd only cleanse our sinful palate and return to the pure, natural cuisine that was ordained for us. Veganism, our cultural anthropologists might observe, is another way we humans like to mark our identities through whom we invite (or don't) to our dinner table and what we put (or don't) in or on our bodies. As such, it's a pseudo-sacred practice for a less doctrinally rigid age (witness the religious words—"awake," "conversion narrative," "zealot,"

etc.—I used earlier to describe changing my diet), where secular hierophants debate earnestly whether one can still be a vegan and eat honey and pass judgment on how to avoid the presence of isinglass in beer.

The fact that I'm English in a movement that draws its ideas and modern history mainly from Anglo-American social thought (with a little Upanishadic or Buddhist lore thrown in for color) only strengthens the notion that animal advocacy is the outgrowth of a particular, sentimental worldview that ignores the very different attitudes toward animals held in other parts of the world. Furthermore, my critics could argue that my vision of what is "natural" or "wild" is bracketed by the fact that Britain has been settled for thousands of years and agriculture has shaped almost its entire length and breadth—the land scaped, plowed, and calved into properties, estates, parks, and *countryside* rather than *wilderness*. It's a small, individualistic frame for a domesticated natural world rather than an expansive, species- and ecosystem-based frame for the rights of, and our responsibilities toward, the untamed. To that extent, the critic might add, with an ironic bow toward my subaltern sensibility, under the guise of spreading "universal values," my British culture continues its three-centuries-long, self-valorizing imposition of its worldview on others.

Of course, Britain is also the country of *les rostbifs* and "mad cow" disease, so the stereotypes work both ways. In my experience, it's a truth universally acknowledged by

peoples of every culture that, while they may occasionally admire the courage of my convictions, they themselves could *never* be vegan. In fact, several famous Anglophone environmentalists, who've fearlessly brought the issue of climate change to the planet's attention, are silent on asking people to *cut down* on the amount of meat they eat, let alone go vegan—as if any removal of animal flesh from our mouths is a position even a radical eco-warrior would consider *de trop*.

Some well-meaning individuals believe we're evolving toward a universal ethic of compassion based on a higher level of consciousness. Those with longer memories ask us to remember how far some societies have moved in the last few decades and contend that vegans and animal advocates are (slowly) winning the argument. Yet as I recall the myriad ways we humans electrocute, cut up, hook, drag, stuff, harness, flay, scald, poison, beat, skin, trap, chase, stick needles and scalpels into, and in too many ways to count manipulate the animals we've captured, that ethic only seems universal in the fact that every society chooses to ignore it.

So, while my observations may, indeed, be conditioned by my cultural background, they don't feel *merely* anything to me—and, I would argue, nor should they to anyone else. Cats and dogs are still being killed for food, cetaceans slaughtered, and bulls harassed and chased through the streets before they're stabbed in arenas surrounded by cheering crowds. Horses are broken, calves

yanked off their legs by lassos, and cocks fought to a bloodied end. Fur sales continue to increase worldwide. Seals are clubbed to death, and wolves and wild horses and squirrels shot as pests. Bile is removed from bears, tigers are skinned, and rhinos and elephants poached for their teeth and nails. If all one needs to successfully defend such practices is to say, "It's our culture," or "We've always done it this way," or "Thus goes the world," then what price human slavery, the trafficking of girls and women for sex or bonded labor, or female genital mutilation? At what point does one heave oneself up from the comfortable sofa of moral relativism and say "Enough!"?

One way of getting one's head around this litany of barbarities is to contend that for all the sound arguments and the continuing discoveries in cognitive ethology that show how porous are the barriers that humankind has established to divide itself from the animals—the ability to handle tools, to employ language, to learn across generations; the application of intelligence to perform functions—we aren't rational creatures, however much we might protest that we alone are capable of altering our behavior based on data and persuasion.

We may hope we can balance interests and agree on categorical imperatives when making moral decisions (including our treatment of animals), but you don't have to be a social biologist to recognize that we're also mortal specimens of appetite and custom. Fearful of losing our powers or dying alone, neither wanting

to be the first to leap nor the last to be left behind, we nervously observe our conspecifics and wonder if we can fulfill our wants without losing our status within the pack or, worst fate of all, being thrown out of it altogether. We envy what others have; yet when we get it, more often than not we want to keep it to ourselves. We turn on anyone who's so different that they threaten the comfortable, unthinking behaviors that perpetuate group harmony, or stop us from getting one over on the others. If we're going to lose everything, we want to make sure that we're not stupid or heroic enough to be the only ones to do so.

The anxiety, craving, and conniving by which we negotiate our way through life appear to have accompanied our fascination with nonhuman animals ever since we became aware of them. Our most ancient forms of art (from cave paintings to our stories about the origins of the universe and humankind) illustrate how the animals that surround us have been the frames within which we've tried to encompass a world in which we lack the speed, strength, body hair, and climbing abilities to survive harsh climates and larger predators through muscle alone. Our metaphors and fables show how much we determine what it means to be human by comparing and contrasting ourselves with other animals. The more we've learned by observing them, by opening up their bodies to read the entrails or ingest their powers, the more we've authorized ourselves to gather information

to dominate and domesticate them, or exterminate them as competition for living space and food sources.

Scientific knowledge hasn't so much eradicated our contradictory ideas about animals as it has amplified them. In the last few centuries, we've confined, mutilated, and determined the entire lives of animals and called them "pets," and done the same to others and called them "food," lavishing love and absurd amounts of money on the former and contempt and as little expense as possible on the latter. We've set up reserves for wild creatures and kept humans out and pushed into extinction hundreds of species by destroying their habitat. We've killed some large animals to draw social and sexual potency from our subjugation of them and our consumption of their body parts. Yet millions of dollars are spent each year to prevent poachers from taking the last few of the same species. We've never slaughtered such a large number of animals or at such a rate, or bred them so intensively and in such number. We ignore the deaths of billions of creatures, walk into the woods to shoot and skin them, and cut them open and poison them in laboratories. But the great majority of us would consider sociopathic someone who beat an individual animal to death on the street.

<div align="center">❁ ❁ ❁</div>

Given these huge inconsistencies, how is one to reason with and within such a schizophrenic species as *homo*

sapiens? I'm no clearer to finding an answer to such a question, nor a persuasive set of arguments that explain either my continuing commitment or the unresponsiveness of others. I admire those who engage in direct action against the industries of animal exploitation and those who work to make and change the laws that govern what is legal to do or not do to other creatures. I appreciate those who raise awareness about what's happening behind the closed gates and doors of factory farms and laboratories. I'm grateful to those who develop meat and dairy analogues or alternatives to testing on animals, and care for the victims of mistreatment. I'm persuaded that if many hundreds of millions more of us became vegans the casualty count would decrease—not least among those who'd otherwise be at greater risk of heart disease, colon cancer, and the illnesses that stem from obesity.

But we need a reality check. Industrial animal agriculture is being exported from Europe and the U.S. throughout the world—especially to China and India—and the feed for the tens of billions of animals is being grown at the expense of rain forest and savannah in Brazil and elsewhere. An apparently insatiable craving for ivory and horn in East Asia and beyond shows no sign of collapsing. Fish stocks are at record lows. Seventeen species of shark face extinction because of the market for their fins. Climate change threatens coral reefs and other delicate bioregions, and the wild spaces and natural

resources upon which all life depends are threatened by human encroachment and development.

The growing of palm oil—an ingredient in many vegan processed foods and products—is destroying the habitat of the orangutan and the Asian rhino; the chopsticks with which we eat our ramen noodles and the boardwalks we stroll upon are constituted of wood felled from the tropical rain forests. We could change these things, if we had the will. Yet we're acidifying the oceans, melting the Arctic ice cap, desiccating the tropics, and defrosting the tundra, all or any of which will bring about a warming cycle and rising sea levels that could render entire ecosystems uninhabitable by any complex life form, including our own. Species are being annihilated that we don't even know exist, yet we can't even save the ones we're aware of—the Amur leopard, the Bactrian camel, the South Asian river dolphin, and so on.

Not only are we doing nothing to slow, let alone arrest, this extinction, but governments around the planet show few signs of grasping the scale of the problems posed by climate change, when they even admit it's a problem in the first place. Instead, we breed and slaughter ever greater numbers of domesticated animals, cutting down the remaining habitat and siphoning off what little fresh water we have left to raise them, pumping ever more drilled and mined carbon, methane, and nitrous oxide into the atmosphere. Seven billion of us want more: more flesh to eat, more milk to drink, more

ivory trinkets, more zoos and aquaria and pets to breed and discard. By 2050, our one species will number over nine billion; how much more then will we command from the remaining species we've not eradicated in the meantime?

It's hard to believe that sound argument or sets of laws will alter that acquisitiveness or change the trajectory for animals. Indeed, since we show no signs of arresting our abuse, enslavement, and murder of our fellow human beings—let alone stopping the continued humiliation of and violence toward girls and women— simply to imagine a world without human mercilessness toward *non*human animals is to conceive of absurdity piled upon ridiculousness. It's not enough to explain our (mis)behavior as simple ignorance, scientific curiosity run amok, cold economic necessity, blatant self-interest, or the straightforward exercise of our belief in our inherent superiority because we're made in the image of God. Something stranger and more disturbing exists beneath our numerous abominations. Valuable though the arguments for animal rights may be, they still depend on an exercise of raw power on our behalf to stop the abuses from occurring and a psychological capacity in some form to cede our (perhaps biological) wish to expand our control over every available space until that ecosystem collapses.

I've recently turned to the tropes of continental philosophy—more for a set of symbols and motifs than for

any systematic response, which given the worldviews that twentieth-century Europe imposed upon its many murdered denizens might be just as well. Claude Lévi-Strauss considered animals good to think with, and Martin Heidegger, Emmanuel Levinas, Jacques Derrida, and others have made good on that goodness. Toward the end of his life, Derrida admitted that "the question of the animal" was the foundation of his entire oeuvre. Indeed, the confrontation or rendezvous with the animal may be the foreground for all philosophical thinking.

Derrida calls vegetarianism an attempt "to buy good conscience on the cheap," an astringent *bon mot* about food choices that omnivorous thinkers who prefer *theoria* over *praxis* love to drop *épater les (bourgeois) végétariens*. Yet the observation echoes some of the dissatisfactions and feelings of incompleteness I have about my response to the endless horrors: that my veganism is merely a heuristic that conveniently buttresses my life and worldview. Following Derrida and others, I see our relationship with the nonhuman world as more akin to war—a conflict that depends on a furious contempt for what surrounds us and has surrendered to our will. The entire animal kingdom has become a repository for our guilt, fretfulness, and fear; our frantic attempts to feel full; and our endless dream to escape the limits of life and death and the arbitrariness of our survival on this planet by imposing ourselves upon it. Under these rules of engagement, the conscientious objection to eating animals' bodies,

while a principled personal virtue, seems utterly inadequate as a coherent counter-strategy to the slaughter.

One consequence of my readings in continental philosophy and sacred literature is that I've adopted a sort of existential advocacy: that it's precisely *because* the goal will never be reached that one must keep working toward it. No prize or glory can attach itself to one's deeds, because no accomplishment can bring us anywhere near the end. Not only is the scale of the suffering immeasurably vast, it's impossible to imagine a world without animal products scattered among or buried within our collective bodies. Try it: the task is literally inconceivable. No effort or self can apprehend it or come closer to achieving it: for every animal rescued from the farm, another takes its place on the disassembly line; for every individual who stops eating animals somewhere in the world, a new person becomes wealthy enough to breed their own, eat meat, buy an exotic animal, purchase a fur coat, and then have more of the same.

And, why not? One might certainly argue that humans should be kind to animals, if only because those who harm nonhuman beings as children may not stop there when they grow up. But when has virtuous behavior ever governed human activity? We might echo Sir Toby Belch's judgment in Shakespeare's *Twelfth Night* that most of us want our cakes and ale as much as, if not more than, the dull rigors of a moderate existence. We want to feel fat and full and jolly. To own animals and/or

to eat meat speaks of mirth, superfluity, rank, and power; being without them entails penury and asceticism. The latter may be worthy practices for monks and Brahmins, perhaps, but for the vast majority of humankind, the delights of the flesh outweigh the purifications of the psyche. With the animal spirits expanding our rounded bellies, we're conquerors; without them, we're weak and passive and easily overrun.

Far from welcoming the shock of the new that becoming aware of what we do to animals potentially represents, most of us don't want to change. We may admire those who campaign against injustice and bring to light the sordid realities of human trafficking, sex slavery, and all manner of abuse, but most of us, most of the time, would prefer not to know or be bothered by what's done in our name or beyond the fences of the bourgeois, well-tended gardens that Voltaire in *Candide* advises us to cultivate. "[H]uman kind/Cannot bear very much reality" wrote T. S. Eliot in "Burnt Norton," observing that we spend much of our life "distracted from distraction by distraction"—finding every way possible to block our ears to information that might impel our conscience and alter our behavior. Like the willfully unknowing Winnie Verloc in Joseph Conrad's *The Secret Agent*, we prefer to be "confirmed in [our] instinctive conviction that things don't bear looking into very much."

Nonetheless, for each meal one saddles up for one's quixotic vegan journey—saved (one hopes) from the

solipsistic nihilism and amorality that might lead to the inhuman acts of Dostoevsky's Raskolnikov or even Kierkegaard's Knight of Faith, by humility: a recognition that one's efforts on behalf of animals are useless and yet they're all one can do. Such efforts require a continual pouring out of the self (akin to the concept of *kenosis* from Philippians 2:7) and its hope of progress, while at the same time maintaining openness to the possibility of transformation. Such an act is a never-ending project of rejection and disappointment. Humility, as Eliot notes in "East Coker," is endless.

To chart our way between what Henry Spira called "hyperactivism" (unstrategic workaholic advocacy that mistakes busyness for achievement) and a passive throwing up of the hands in despair requires discernment. Discernment, of course, is a faculty linked with observation, but it doesn't rush to judgment about what it sees. It takes in everything it can and then lets the material reveal its core or essence. The reward is that most subtle and evasive of visual correlatives, *insight*. Discernment inherently honors a maturer eye, one tempered by the recognition of nuance and complexity, open to the failures to persuade and all too aware of how the hectoring voice or the finger jabbed in another's direction can close off the avenue of transformation and shut down the stirrings of scruples in the person you're trying to reach.

Discernment is not a soft option: it requires an hon-

esty and precision that cut through the misleading and the simplistic so we confront the choices we'd prefer not to realize we make all the time without thinking about them. The practice of discernment encourages us to act, literally, in good conscience and in such a way that we can tolerate reversals and continue the work we're called upon to do over the long haul. In its honoring of discipline and our weaknesses, discernment necessarily reaches beyond the rigidity of dogma to encompass the messy and humbling disclosures of the spirit.

It comes as a surprise to me that, after countless hours of activism and marshalling arguments, I find myself in such a place. Even the word *spirit* stirs up anxiety at a presupposed lack of philosophical or scientific rigor, of a privileging of emotion and sentiment over reason and the intellect—an old motif that for decades has been used to tamp down our undoubted enthrallment with other animals and stifle objections to practices that hurt them. A few years ago, I'd have been the first to argue that the case for animal rights offered no space for mystery. After all, although many of the world's faiths contain a version of the golden rule that could extend to nonhuman animals as well as our human brethren—and present sutras, verses, and doctrines on how they should be treated compassionately—their texts have also been used to justify our rampant, thoughtless exploitation of the other-than-human world.

By evoking the spirit, therefore, I'm not attempting

to align with a particular religious doctrine. Instead, I'm bringing to mind the *spiritus* (Latin) or *pneuma* (Greek) of the inhalation and expiration of air that activates the entire autonomic nervous system and allows all mammalian life to function. In that it both precedes and expresses consciousness, is invisible yet essential, the embodied breath is at once immanent and transcendent. It's the Hebrew *ruach* that God blows into the clay (*adamah*) that quickens the earthling (*adam*) (Genesis 2:7). It's the all-encompassing *chi* (Chinese), *ki* (Japanese), or *prana* (Sanskrit) that energizes the universe. It is, surely, the ultimate frame for our "being in the world."

I also want to echo the ghostly presences of the *genii loci*, the protectors of the groves, rivers, and forests in the ancient religions before the rise of monotheism and materialism de-animated the natural world. These beings continue to live on in notions of metempsychosis, vision quests, shapeshifting, ancestor worship, and even our continued fascination with the undead, lycanthropy, and vampirism. They inhabit the recesses of our sympathetic imaginations: where we find ourselves uplifted by the sight of a bird in flight and disturbed by the felling of a tree. Those moments when the natural world ignites us as "kingfishers catch fire, dragonflies draw flame" (to quote Gerard Manley Hopkins) express, like the metamorphosed human-animals and god-creatures of the Asian, classical, and gothic imaginations, a crossing

of the threshold from the world of ordered taxonomies that define who is morally considerable and what is not into a liminal space where we imagine ourselves within a different body and the borders that separate "us" from "them" are no longer as distinct.

As in all passages across the threshold, we need a psychopomp to guide and translate for us. To the ancient Greeks and Romans, the traditional transporter of souls between the living and the dead was Hermes/Mercury. Yet Hermes wasn't always reliable. As his name suggests, he could be mercurial, willful, even a trickster who leads us astray. As the god of interpretation, Hermes continues to clarify and garble the wisdom he delivers. But who else will carry us between light and dark or take us beyond the frames of the looking glass in which we see a face so like and yet so unlike our own? Who else will provide us with a mirror to flip the image the right way up when we pass into the topsy-turvy *camera-obscura* world that lies before us?

It is Hermes' legacy that any presentation or representation contains within it that elusive/illusive quality of art, which at once holds up a mirror to nature and yet can delude and misdirect the trusting eye. Framing accompanies every effort we make to interpret and appreciate what or who is between the borders of the photograph, including (naturally) the thoughts and judgments contained in this book. Framing excludes as well as includes, reorients your eye to regard what it wants

you to discern, and attempts to occlude what it wants you to ignore. So, at the risk of being framed by being framed, we move to the frames of Jo-Anne McArthur's We Animals series and the photograph of the polar bear in the Toronto Zoo.

Perspective

CAPTIVE ANIMALS OFFER a number of practical advantages to the photographer. You don't need to traipse through the forest or wait for days for them to emerge from the bush or canopy to take that perfect image. The animals you're interested in shooting may be inured to the presence of humans and thus less skittish or unpredictable in your company than those in the wild. The physical closeness of the animals in the confined space of the zoo or studio can allow you to compose and light the shot in a way that would be much harder to arrange *en plein air*.

Barry Steven Greff's portraits of large mammals and birds, entitled *Of the Wild*, consist exclusively of close-ups of animals' bodies and heads. On his website, Greff discusses his decision to take photos of animals in zoos or wildlife refuges where "[t]hey are protected from me

and I am protected from them" and he has "the luxury of observing and recording their beauty in this intimate space." The zoo affords, he adds, further benefits:

> In their natural environment these animals would be faced with the struggle to survive within the same fragile ecological environment that we all share. So, we have a lot in common with them. In the zoo ironically the animals and birds are protected and safe. My images capture the life force that is simultaneously controlled; yet untamed. They are on display for human enrichment and education. I rejoice in having the chance to record their natural beauty and splendor. I also see that they are similar yet beyond the foibles and faults of the human condition that I am very familiar with. The dichotomy of this containment in a zoo (hidden within my images) of being both on display and behind bars, alive but enclosed, is a metaphor for our own human condition.

Tim Flach also uses animals in captive breeding programs and zoos, although his portfolio extends to insects, jellyfish, and bats. Flach's photographs are all set in a studio against neutral-colored screens to foreground the face, musculature, and texture of each animal's body. Flach closely examines a palm, an ear, hair, and even pupae. Unlike Greff's, some of Flach's photos feature more than one of each species within the frame.

Flach's aim (and the *raison d'être* of his shooting animals indoors) is not so much to compare these creatures' lives with our own or to celebrate the possibilities of tension between wildness and confinement, but to question what either might mean anymore given that human beings so dominate the world's ecosystems. Although Flach spent hours and even days waiting for some animals to act "naturally" (the peacock to fan its feathers, the bonobos to embrace, the anteater to roll into a ball, the cobra to puff itself up in display), he makes clear that he knows the shots *feel* posed. His intent, he writes, was for the animals to approximate a "form and shape that reminds us of ourselves."

James Balog's *Endangered Wildlife* photographs, like Flach's, celebrate their artificiality. Balog aims to question the premise that what the captive animal offers to the eye is in some way a false representation of that creature. In an interview with Susan Reed of *People* magazine, Balog stated: "I wanted to strip away normal visual distractions so that people could look at the animals as aesthetic sculptural forms. . . . And secondly, I wanted to correct a romantic illusion perpetuated by wildlife photography that these animals are living happily in some idyllic landscape. I wanted to show that these animals are now alien on this planet. They are not living happily ever after."

All these photographers' works demonstrate how much we're attracted to faces. The face offers a way to make a connection with someone, to interpret their

emotions, or (following the ancients) to read that individual's soul through the eyes. We like to assume that we humans can read faces—even though, as we've discovered with nonhuman animals, our judgments can be wrong: the chimpanzee's grin, for instance, is not a sign of happiness but fear, and the "smile" formed by a cetacean's mouth is an illusion. Like many animals, we react if eye contact is held for too long. We either look away or respond to it as a threat or a challenge for dominance. The combination of bonding and danger that occurs when you come close to an animal is something that Greff hopes we go through as we stare into the eyes of the wolf, lion, gorilla, and eagle, with their gaze trained directly on the camera: "By abstracting the eye or face from the rest of the body, I force an intimate exchange of energy and focus between the image and the viewer."

Flach wants us to recognize our complicity in neoteny, an attraction to animals that have the short limbs, big eyes, and large head in proportion to the rest of the body characteristic of human infants. The world, he notes, is mainly filled with "small brown things" (which are rarely photographed or used as the poster children for environmental protection); instead we're drawn to lions, bears, tigers, elephants, etc., who possess traits that we find admirable or retain a symbolic or physical power that we fear, honor, or wish we had. Our privileging of these beings in thinking about whom to save and whom to let fall extinct is, says Flach, a further confirmation of

the bias of attention we pay to species either similar to us or that we're in awe of.

Greff, Flach, and Balog are committed to conservation. Nonetheless, in spite of their expressed hope that the images may make the viewer aware of how habitat for wild animals has been deeply compromised, and how each of us is likewise hemmed in by a world devoid of the genuinely natural, their portfolios tell us little about life for these animals in captivity. Although Greff states that all animals (human and nonhuman) struggle to survive "within the same fragile ecological environment," he doesn't elaborate on or depict who might be responsible for that ecosystem's vulnerability or whether nonhuman animals are as equally maladapted to the world they live in as human animals are. Lions clearly survived adequately in their bioregions before humans hunted them to (near) extinction and/or put them in zoos for their own safety. Somebody made it hard for them and that somebody was, and remains, us.

These men's photographs are exquisitely composed, even playful. The animals' shades and coloration, the texture of the hair or feathers or fur, and their curves and musculature leap out at us from the images. Nonetheless, for all that beauty, the emphasis on the "aesthetic sculptural form" transforms the animal from a motile, enlivened being into something static and iconic. By posing these animals in situations that are so obviously artificial—lounging by a swimming pool, emerging from

behind cream-colored drop-cloths, caught mid-leap between one chair and another, and sitting on a stool (as in some of Balog's depictions)—the photographers redirect the viewer from the context within which these animals'"beauty" developed.

Indeed, by stressing that, in Flach's words, these animals have a "form and shape that reminds us of ourselves," the photographs imply that the creatures now exist *to be* looked at by us. We're the ones who can confer on them *our* appreciation, as opposed to that of their conspecifics, because "they" are "us." These animals may be "beyond the foibles and faults of the human condition," as Greff proposes, but by setting them within a human *imaginative* as well as physical frame, the photographers erase the fact that the markings and textures of the animal's face and body serve a nonhuman purpose in the wild—what Balog perhaps means by "normal visual distractions." It's an irony unacknowledged by these photographers that the very coloration and textures that we're invited to admire may not be an aesthetic choice but a survival mechanism, intended as camouflage, intimidation of would-be predators, an adaptation to the local climate, or a signifier of an animal's sex or wish to reproduce.

In sum, we're asked to regard these endangered species before they vanish from our sight in the wild; yet the more we look, the less we actually see them as they are in nature. That, of course, may be the point—to be empha-

sized or subverted: that these wild animals are artificial, constructed totems, who may be "more than human," but whom our gaze turns into as exactly human as we'd like them to be. Our aestheticization is an anaestheticization; what is to be memorialized is marmorealized instead.

The emphasis on sculptural forms also risks rendering the creature emblematic of how we believe a certain species should represent itself metaphorically to us: the lion is noble, even regal and the tiger is predatory, its long canine teeth bared; the eagle is sharp-eyed and the peacock is flamboyant; the snake rears up threateningly and the elephant spurts water playfully; the various primates pose in ways that emphasize their "humanness" (a hand clasped on the forehead, orangutans gathered conspiratorially, a gorilla looking grumpy). For all the novelty with which some of the animals are photographed and the exceptional detail the images display, the viewer nonetheless sees what he or she expects to see: the rhino's rump is suitably armor-plated; a leopard leaps in a feline blur; the porcupine is prickly; the tigers burn bright; the baboons look anxious; the panther is crafty and feral. And they are solitary—except for the amphibia, reptiles, and insects, who are, in Flach's photos, always displayed in multiples, to affirm our prejudice that mammals possess an individuality that "lower" creatures do not. Only rarely do we see animals within a family or troop. Unlike Balog, neither Flach nor Greff name, locate, or date the

photographs of their animals, and we're not told which zoos or sanctuaries these animals came from.

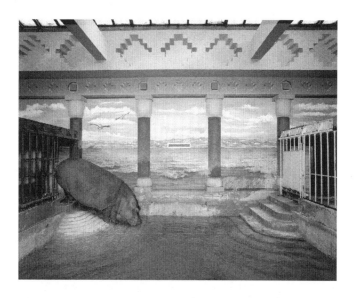

In *Captive Beauty*, Frank Noelker adopts a different method to examine how we see animals in a man-made surrounding. First of all, he names the species, locates it, and dates the picture: for instance, "Hippopotamus, Washington, D.C., 1997." In this photograph, the first in the book, a hippopotamus is seen walking gingerly through an open gate in a metal fence, down a short concrete embankment, and into a pool of green water. On

the other side of the pool a flight of steps leads to a metal fence and a gate that's shut. Behind the pool, four burgundy-and-yellow-colored columns support a vibrantly decorated entablature. Between the columns a mural depicts two birds winging their way over an expansive wetland that stretches to a snow-capped mountain range on the horizon.

Throughout *Captive Beauty*, we come across zoos that have, with more or less skill, painted landscapes on the walls of the animals' pens. What's remarkable in this photo is the enclosure's *mise-en-scène*. It's as if the hippo has visited a Roman bath, and is simultaneously availing itself of the healing waters and strolling through a gallery. This image and a similar one of a giraffe in the same zoo take the aestheticization of the animal to another level. They form a *tableau vivant* that deliberately, even garishly, celebrates a constructed world of balanced combinations of patterns, colors, and shapes.

In its formal arrangements, the picture exemplifies the history of the zoo that Nigel Rothfels charts in his thoughtful introduction to *Captive Beauty*. From the earliest days of civilization, Rothfels notes, potentates all over the planet have collected animals in menageries for private viewing as a demonstration of their power over their own and other peoples, and their mastery of the natural and political geographies of their time. During the eighteenth and nineteenth centuries, these collections morphed in Europe into representations of the

clout of the post-Enlightenment state. Zoological parks were places where the urban bourgeoisie could enjoy a safe and pleasant stroll to see exotic animals and be seen by their fellow citizens.

These institutions were also the logical correlative of our centuries-long endeavor to turn unkempt nature—with its many ecosystems and biomes; its infested swamps, dense jungles, and mountainous seclusions; its inaccessible aeries, hidden dens, and secret burrows; its multitudes of animal families and diverse species in predator–prey symbiotic relationships—into a walled garden, ridged terrace, or hedged field that betokened civilization and a landscape controlled and organized for our consumption, edification, and pleasure.

Although some zoos over the last few decades have reoriented their mission toward conservation of, and education about, endangered species, these viewing platforms illustrate that zoos still present themselves as providers of entertainment and amusement. In that respect, Noelker's photographs admirably illustrate how the zoo establishes another set of frames that connote the triumph of civilization: the theater, gallery, or exhibit hall. Inside these borders, the individual animal (no longer hidden *from* us but displayed *for* us) is a "feature" (as opposed to a member of a family group) in a deliberately unnatural setting that always remains the same, unaltered by the creature who inhabits it and resistant to the changing seasons or weather patterns. The enclosure diminishes

the ecosystem to a few components (real or otherwise) and clears away the distractions (as Balog wants) to let us *see* the animal. At the same time, its backdrops, wings, exits, and entrances remind us that the creature is meant to *perform* for our appreciation.

(One might observe, of course, that the continued popularity of nature films, TV reality shows like "Big Brother," and public media platforms like Flickr, You-Tube, and Instagram, show how the camera now serves as *the* medium for how all of us understand social inter-action between family members of whatever species. Whether we like it or not, we're all performers, our exis-tence only *real* when edited and uploaded and subject to the gaze and instantly constructed storyline—one we tell ourselves, and a more persuasive one determined by others.)

"Hippopotamus, Washington, D.C., 1997" offers an example of what we might call the alchemy of artifice that unites the images in *Captive Beauty*. The process of turning dross into gold entails physical and psycho-logical refinement as what is earthen and quotidian is transformed into something extraordinary and precious. The alchemy of artifice that occurs in the photographer's studio and the hippo's pen involves the sloughing off of excessive embodiedness—ordure and semen, and the acts of copulation, smelling, digging, mud, and predation—to find the irreducible and unchanging quintessence of the creature in question: the nobility of the lion, the bathing

beauty that is the hippo of this natatorium or Disney's *Fantasia*. For this transmogrification of base into gold, our own eye must be refined through the exquisite composition of the photograph or the symmetry of the hippo's enclosure. As such, both human and nonhuman move from animality to *anima*—the soul that exists beneath the skin and is revealed and entrapped by the decaying physical body it longs to escape.

The alchemy of artifice aptly describes the studio photography of Flach, Greff, and Balog (how scrubbed and brushed and ready for their close-up the animals are!) as well as the near oxymoron that lurks behind the title of Noelker's book. Flach, Greff, and Balog all want to demonstrate that captivity enables us to focus on the beauty; that, in fact, the clean lighting and defined landscapes allowed by that framed existence are an essential part of that beauty. Yet what "Hippopotamus, Washington, D.C., 1997" literalizes is how deliberately cosmetic such beauty is: studio lighting, the application of paint and optical illusions, the removal of unsightly physicality. The reality shopped by these photos is entirely constructed.

Consider Noelker's image "Giraffe, New York, 1997," where the animal walks alongside an expansive painting of the African savannah. Noelker eschews the close-up in favor of the more removed and, dare we say, less discriminating perspective of the ordinary zoo-goer. Far from hiding the containment, as Greff wants to do in his

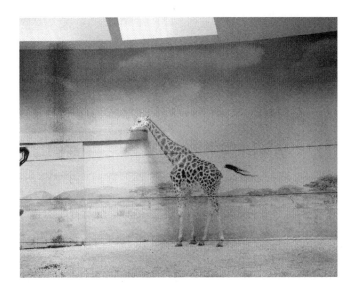

images, Noelker clearly shows three lines of wire fencing cutting through the scene. A harsh light off-camera casts the giraffe's shadow onto the flat surface of the mural, the plane of which is broken by the lintel and sliding door into and out of the enclosure. These literal and meta-phorical frames disrupt and deconstruct the savannah's proclamation of "naturalness" and "spaciousness" and underline the fakeness and confinement of the framed, painted landscape.

In another picture, "Lion, Los Angeles, 1998," the animal sidles along the edge of a moat filled with dark green water. Behind him loom enormous rocks painted on a wall, which is, one assumes, high enough that the

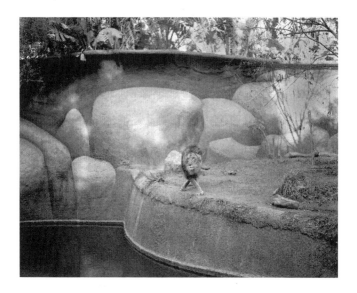

lion cannot leap out of the enclosure but not so tall that the tropical shrubbery that flourishes beyond the wall is kept from our view. The abundant plants outside of the pen grow in stark contrast to the struggling strands of grass and the bare-branched tree within it.

The savannah in the giraffe's enclosure and the boulders in the lion's are not so much *trompes-l'œil* as a rococo flourish, since they don't fool *our* perspective but, more cynically, allow our eye to appreciate a dab of faux foliage in a world devoid of it. In the lion's den, these sham rocks direct our gaze toward the genuinely animate matter beyond the wall. Even if this exercise in cut-price *quadratura* representation might partly salve our

consciences that these animals are *at least* being given the illusion of space, rather as we might plaster an alpine scene onto a wall at the office to provide some ersatz chlorophyll among the gray cubicles, are we not in fact simply providing ourselves with the cheapest of thrills in the multiple illusions in front of us: the fake boulders, the false perspectives, and the pseudo-wildness? We're back in the studio, where all is pretense except for (or, perhaps, as well as) the live creature in our midst.

Because Noelker's photographs step back from the close-up and survey a wider canvas than the other work we've discussed, we glimpse—along with the compacted mud, dead wood, sawn-off tree trunks, and occasional tufts of grass and animal droppings that speak of the incarnate life behind bars—various cables, ropes, wires, grates, taps, tiles, latches, and hinges: the occasionally rusted or corroding paraphernalia of confinement that attend the ordinary lives of zoo animals when they're not removed and buffed or lit so their hide is suitably weathered, wrinkled, or sleek.

In *Thought to Exist in the Wild*, a book she co-authored with environmental writer Derrick Jensen, Karen Tweedy-Holmes offers photographs, all printed in black and white, that also show the bars and fences of the zoo, but provide a slightly different standpoint than Noelker's. The text that accompanies each animal not only gives the name of the species in English and Latin but tells us where the animal is found in the wild. We're reminded, if

only in the caption, that animals are not sculptural models or works of art—manifesting themselves in front of us, as though in a gallery—but that they once possessed a nominal *lebensraum*, even if they were taken from it as infants or were born in a zoo.

As the title of Tweedy-Holmes' book implies, and Derrick Jensen's pungent essay affirms, the animals behind the bars are figments of our imagination (*thought*). They're residual symbols of foreign lands, strange beasts, and other exotica that hint at the vicarious thrills we might have come across on the scientific expeditions/raiding parties that originally brought these animals to the cages. They're an opportunity for us to be genteelly horripilated as we imagine what it might mean to be "wild"—beyond the boundaries of civilization and its comforting customs and hierarchies. Finally, these animals are embodiments of their own endangeredness: that we're not sure they can be said any longer to *exist* in the wild, either as a viable species or if, by "exist," we mean possessing a life untrammeled and unaffected by human encroachment on their space.

Like Greff's and Balog's specimens, Noelker's animals are almost always alone, emphasizing their representational abstraction and their isolation. Like Noelker, Tweedy-Holmes depicts the boredom, lifeless environment, and the barred and caged reality for too many animals in zoos today. But her photos also show animals as relational beings as opposed to "objects" that exist to

stimulate our pity or fetishized appreciation. Many of
Tweedy-Holmes' photos feature more than one animal:
a pair of pandas lounge on a rock; two elephants stroll
around their enclosure; one Japanese macaque grooms
a mother, an infant suckling her breast; a giant anteater
carries her child on her back; a brace of guanacos wrap
their necks around each other; and so on.

These images compel us to acknowledge that
although we may wish to believe that the animal in the
zoo is a representative of its species (the self-serving
word "ambassador" comes to mind), it's likely the ani-
mals view themselves, as it were, differently. The Western
lowland gorilla whom we see nursing her baby is, one
assumes, looking after *her* child, whom she's either given
birth to or has adopted. Although we might observe that
the gorilla's maternal feelings accurately mirror those of
Western lowlands, and perhaps all, gorillas (or even all
primates, including us), the infant she's holding in her
arms isn't abstract or merely representational to her.
She's not nursing the baby as a duty to her species or
to demonstrate to us how Western lowland gorillas look
after their young: this is her child, and no one else's.

Once we recognize the specificity of the individual
animal within the context of his or her family—when the
"it" of the generic creature and species becomes the "her"
or "him" that possesses singularity within the "them" that
is their troop or herd or flock—we're obliged to recog-
nize that animal's or those animals' common connection

to us. When we acknowledge that when we speak of animals we mean not only individual beings but clusters of relationships, we inevitably find ourselves at the bolted and barred gates of personhood, that human-constructed citadel around which we've built the high walls that we hope will separate us from the other animals and that we patrol in case other species mount it on their own terms or without our permission.

* * *

Photography and confined animals, of course, are connected beyond the practical utility that a zoo offers in having wild animals at hand. As we've seen, the photograph and the zoo frame an animal for our pleasure, interest, or education. They delineate space and context that combine illusion and the occasional eye-opener when we look within the frame.

The words *capture* and *captivation* themselves signal the dualities of the photograph and the zoo. On the one hand, the viewer is encouraged to assemble a set of beliefs and impressions about what's arrayed in front of her. We assume the photograph is a more accurate depiction of reality than a painting, or our memory, or, indeed, (a thousand-fold) the words we deploy to describe the scene. On the other hand, the *capture* of the animal and the photograph distort the space by holding it hostage between the frames of a constructed reality. The capture

allows the eye to focus and potentially be captivated, but is what it captures *true*?

Within the photograph and the zoo, the animal is caught in a moment that abstracts the individual's life and buttresses the beliefs and impressions we have about the species that that individual represents. Our belief that undomesticated animals and livestock express "behaviors" whereas we and our "pets" have "personalities" means that the zoo animal's individuality, if we could discern let alone define what it is that makes him particular and not someone else, is overwhelmed by what we assume to be the "behaviors" of the generic animal.

The generalizing mind no doubt served a useful purpose for our ancestors as they climbed down from the trees and became bipedal scavengers on the open plains. Their brains needed to recognize patterns of behavior in the animals they hunted. Otherwise, they wouldn't have been able to run down their prey, set traps, or predict which animals were likely to be in a particular place at a particular time. One might conjecture that as our brains expanded and we began to separate our consciousness from the fauna around us, we probably relied heavily on animals acting predictably and therefore *appropriately*, so we could shape our world around their movements and characteristics and exploit them to the fullest.

When an animal starts to behave differently than we expect, the taxonomies and other organizational criteria by which we orient ourselves to the world are

shaken. If, for instance, a bear began to walk or swim in ever more constricted circles around his enclosure and spent minutes at a time staring at the world beyond it, we'd inevitably begin to think that the animal was not behaving "normally." Before we knew it, categories of the human realm that we've jealously guarded would begin to seep into the nonhuman world. The animal would be "lonely" or "bored." We might start to wonder whether it's cruel to keep this creature locked up in the compound and rush to find ways to keep him interested. In so doing, we'd inherently be questioning how representative this animal now is of his species. Has confinement warped and twisted his lion-ness or gorilla-ness so that he's no longer genuinely what we assume a lion or gorilla to be?

These aren't theoretical questions. We've learned, tragically, from raising chimpanzees in domestic situations that once they've grown too strong, unruly, and "chimp-like" to remain within their human families they find it hard to bond with their conspecifics. Neither they nor their fellow chimps consider themselves members of the same species, which demonstrates how the ability to recognize ourselves in others and determine what is or isn't behavior befitting our species is also not something confined to *homo sapiens*. Equally tragically, we've seen that even though they may grow up in the company of humans, wild animals like tigers and chimpanzees can "inexplicably" express their feral nature and cause harm

or even death to the human beings with whom they've supposedly bonded.

So a captive animal is not only *a* representative and representative, but a representation. It's an example of what an animal "is," a copy of every other animal like it, and potentially an artificial creature, distorted by confinement and the (mal)adapted *performances* that confinement now elicits. Inasmuch as we invest the animal with singularity and authenticity—this is who *this* individual animal is and *this* animal is evidencing its particularity— we acknowledge that we cannot really tell what is specific to *this* animal and what is common to the species, without also admitting the possibility of a breakdown in categories that would mean that the animal is no longer behaving as that animal "should" behave. *If it becomes too like us because of its confinement, it's no longer a representative animal. If it's no longer representative, then what's it doing in the zoo?*

The zoo setting amplifies these paradoxes of individuality/species and natural/artificial. An individual animal is placed within an enclosure tricked up with representations of the natural world to provide the watcher and the watched (and who can tell who is who?) with the illusion of an ecosystem, the scrim of habitat, and pseudo-feral behavior common to the animal's species: all in the service of some idea that we're in the presence of something that belongs to the "natural" world. The challenge of representation is that authentic-

ity cannot be assured unless we confer it, at which point we have to "forget," as it were, the possibility that that authenticity is heuristic. And by observing the individual animal behave distinctively, we risk the possibility that the animal is not behaving "naturally."

 * * *

As a photojournalist, Jo-Anne McArthur sees it as her vocation to document and expose the lives, and deaths, of animals. We Animals has a broader ambit than the other photographers' portfolios, since it archives the worlds of companion animals and livestock as well as exotic species in zoos and entertainment. Unlike the studio photographers, McArthur doesn't want to disguise the confinement of the wild or domesticated animals she shoots. In fact, she draws attention to it. More starkly than Noelker's animals, McArthur's creatures are often literally shadowed, partitioned, transected, and framed by the chains, barricades, locks, catches, racks, cages, grilles, fences, bars, and crates behind, upon, or within which they find themselves. In the case of the animals in zoos and aquaria, their enclosures may even be located next to photographs of the wild places where they came from, literalizing Jensen and Tweedy-Holmes' titular concept. In a couple of examples, the animal can be seen confined within an enclosure that is only yards away from the creature's natural habitat.

To emphasize the "caught-ness" of the animals, McArthur's photographs rarely take the form of "portraits." The animals are often depicted off-center, shot from above or below or at an angle. It's noticeable that when McArthur replicates Noelker's photographs from the Washington, D.C. zoo, she chooses not only to shoot in black and white, but in the case of the giraffe, focuses the camera on the feet and the concrete beneath them, severing the animal at the neck. These decisions suck any illusion-generating and prettifying cosmeticization from the confinement and stress how quartered (in both senses of the word) these creatures are.

As a collection, We Animals demonstrates that in their captured state those animals whom we display before visitors in a zoo are little different from those who are coerced into performing for us in circuses, are objects for our amusement in rodeos, are subject to experimentation in laboratories, or are warehoused as foodstuff on industrial farms. They all endure cramped and curtailed existences, shunted between sets of gates and pens without any agency of their own.

McArthur makes no secret that she sees her work as advocacy. Yet her photographs reach beyond agit-prop, not only because of their thematic coherence and her obvious skill at composition, but because she doesn't seem interested in vilifying those who make money off the backs of those they exploit. McArthur's focus is too generous and her eyes too "open" to assign blame or

dispense forgiveness. She takes everything in and lays a scene before us, trusting the power of (her) artistry without feeling the need to descend to sensationalism. And, as image after image demonstrates, blame and forgiveness are beside the point, since through our patronage we're all complicit in allowing the routine despair to continue. We co-opt and consume these creatures' bodies and their functions; we stifle their most fundamental behaviors. We choose to look or not to look, and do nothing.

The fundamental difference between McArthur's series and the other photographers' is that McArthur's shows, as her title makes evident, that we're animals, too—however we might choose to view other-than-human animate life, or honor or dishonor, puzzle over or characterize, our relationship with it. We also fall prey to parasites and sickness, are propelled by impulses encoded in our genes, and find our pursuits limited by others enduring the same conditions. We cling tenuously and compulsively to life. We're naked and helpless when we're born and, as the Bible notes, we bring nothing into the world and carry nothing out (see 1 Timothy 6:7).

That fundamental commonality is represented visually by the fact that, unlike the other photographers' portfolios I've covered here, McArthur often places human beings within the frame. A young woman laughs in delight, unease, or embarrassment (or perhaps a combination of all three) as she cradles a pre-processed alligator handbag in her arms. A boat full of tourists, cameras

and cellphones clicking, leans toward a patch of river-bank where a gator appears to shrink before their attention, the reptile's fish-eye lens no doubt mirroring the one through which these predatory paparazzi were observed. A man clasps two chickens by their legs (a bird in each hand) to be lugged to slaughter. A tourist at a temple in Thailand poses for his friend to take a photo of him standing above a comatose, chained tiger. A Buddhist monk hovers over another tiger. One recalls the Sanskrit chant *lokah samastah sukhino bhavantu*, "May all beings everywhere be happy and free." Presumably, the tiger is working his way up the karmic ladder by bringing valuable donations to the monastery.

These and other images taken by McArthur remind us that, for all our fascination with the beauty of our

fellow creatures and our concern for their being endan-
gered—indeed, in spite of our earnest hopes that zoos
may protect these animals and ensure their continued
survival—these creatures are, like the billions of creatures
not in zoos, still living at our whim. (To that extent, Greff
has a point when he notes that animals in zoos are at
least somewhat protected from human beings.) McAr-
thur's photographs catch chicks for sale, dairy cows and
veal calves in their stalls, elephants chained, calves roped
in rodeos, bears farmed for their bile, etc.

McArthur's journalism demonstrates that for all their
ubiquity and our desire to *see* them, the animals are also
perversely *invisible* to us and that our wish to control
their behavior can also take the form of neglect. Several
photos illustrate how, in spite of the allure of the animals'
pelts, coloring, and that elusive beauty, we often forget
or overlook those whose lives we compulsively meddle
with. They're thrown away as trash, left neglected by the
side of the road, packed into bags or trucks, or discarded
in the stockyard: surplus supply to a demand that seems
never to be exhausted.

Unlike Greff, Balog, and Flach's exquisite *objets d'art*
or Noelker and Tweedy-Holmes' creatures behind bars,
many of the animals in McArthur's photographs have
had neither their bodily integrity nor their beauty
respected—even if they're not being used for our food or
entertainment. In one arresting image, the right-hand
side of a hawk's head, richly endowed with brown-and-

white plumage, stares directly at the camera. One is reminded of Barry Greff's anticipation that "by abstracting the eye or face from the rest of the body," an "intimate exchange of energy and focus between the image and the viewer" is generated. And it's true, the animal seems emphatically alive and present to our look. However, it takes no more than the bat of an eyelid or click of a shutter for us to realize with a shock that the face has indeed been *wholly* abstracted. All that exists of the bird is the head, which rests upon a broad, spotless table. In the background, the blurred images of desks and overhead strip lighting reveal the stage; the caption tells us that the photograph was taken in an anatomy and dissection class at Canadian University in 2007.

The photograph of the hawk's head dramatizes two

opposing ideas about what it means to learn about the natural world—ideas that frame all the photos we've discussed in this chapter. The first impulse is to observe the animal in its natural environment, and thereby try in some way to appreciate that creature and its world. It's a belief, espoused most passionately by Derrick Jensen in *Thought to Exist in the Wild*, that the animal we see is simply not the animal we think we see outside of the context of its environment. Quite simply: a brown bear is not really a brown bear without the habitat (the frame) in which the animal evolved and in which it can fully express its behavior.

Such a view inverts Heidegger's argument that one of the differences between the animal and the human is that the former, as he puts it, "lacks world." In other words, the animal doesn't appreciate what Heidegger terms *Das Existentiel* beyond its sensate existence; although it has a physical sense of its body moving through space, it lacks our metaphysical realization of being-in-the-world. Of course, we can only intuit other humans' possession of self-consciousness and world-awareness from the fact that we personally have both. Given the possibility that our fellow humans could be merely mimicking conscious-ness or that we ourselves might be deluded about what our senses relay to our credulous brain, such separations between animals and us must remain purely speculative, no matter how "obvious" they may seem.

Jensen's comment reminds us that the observational

apparatus we employ to determine the world-awareness of animals is based on a conviction that our way of looking is inherently superior, especially in measuring what is or is not worthy of inspection or collection, because it is *we* who are doing the looking. If we were being honest, we'd admit that we have no way of assessing (to roll out Jakob von Uexküll's term) the *Umwelt* of the bat whose world is echo-located, the whale who can compose and listen to unique songs across miles of ocean, the elephant whose rumble vibrates through the savannah, the traces that leaf-cutter ants make within the forests, or the scented or electromagnetic migrations of salmon or birds. Come to think of it, how might we map the sonic landscape of the beheaded hawk, whose right ear listens intently to the hum of the strip lighting in McArthur's silent laboratory?

We're incapable of conceptualizing the self-organizing "civilization" of the anthill or the termite mound or comprehending a zebra's or wildebeest's consciousness within the million-strong herds that migrate between the Serengeti and Masai Mara each year. In the last instance, we can only focus on the one, let alone the ten, the thousand, or the million. Given that we cannot understand the individual animal's *Umwelt*, then what hope do we have of considering that of the herd or that which exists among different species in the broader ecosystem?

This is not, *pace* the discussion that has appended itself to Thomas Nagel's famous essay on what it might be like

to be a bat, a matter of linguistic definition, the episte-
mology of consciousness, or a failure of the imagination.
I'm arguing that, in spite of cognitive ethology's enlarge-
ment of our appreciation for the sophistication of other
animals' sensory worlds, we still expect evidence to relay
itself *visually*. Discernment and insight etymologically
privilege the eye. Even our organization of the biosphere
shows our bias toward sight. The word *species* is derived
from the Latin *specere*, "to look at," because according to
Encyclopedia Britannica the various species were originally
organized by their similar *observable* traits.

Unable to escape the dominance of the eye, we've
concentrated our gaze more minutely. Save for recent
work in ethology, we've placed an undue emphasis on
what the zoo and the laboratory sees—a presentation
that presupposes that an animal is most completely,
accurately, or (paradoxically) *appropriately* or *adequately*—
understood under controlled (therefore human) settings,
where the creature's components can be disassembled,
anatomized, and isolated so that the underlying struc-
tures of that being's physical existence can be dispassion-
ately comprehended.

In response to Heidegger and the above, Jensen
would no doubt agree that it's we and not the animals
who are world-poor, not only because we still cannot
appreciate the subtlety and complexity of the sense-
world within which many animals exist (one long
physiologically and perhaps psychologically closed to

us) but that we've too often failed to lift our eyes from
the microscopes and gone into the wild to deconstruct
the anthropocentric contexts for our understanding
of the animal. Balog may, indeed, be correct that, in
many areas of the planet, these "animals are now alien.
. . . They are not living happily ever after." But is exis-
tence as a DNA strand or in a zoo really preferable to a
compromised habitat? And is such a witness-protection
program—for are we not, in effect, hiding our chosen
animal, the one who performs such valuable work for
us, undercover in plain sight in a "safe" location where
it and we won't be killed—really *living*?

The mindset of the laboratory reduces the bird's
eye to an instrument of sight, composed of lenses,
retinas, and other mechanical processes—like a cam-
era, in fact. Unable to mimic the bird's flight except
through mechanization, we turn the creature into an
instructional tool. McArthur's photograph is unsettling
because, for all of the barrenness of artificial light, the
ordered array of desks, the absence of any living thing,
and the dead creature on the human-made surface,
it's impossible not to feel *seen* by the bird's eye. That
gaze, so piercing and so critical (!), meets our own and
inquires whether we *really* observe nothing, nothing
at all, behind the lens. McArthur's shocking literaliza-
tion of the head's abstraction from the rest of the body
highlights the artifice of Greff's aesthetic object—the
animal as emblem—and illustrates our mind's wish to

reincorporate the animality into that collection of body parts, an "intimate exchange" that does not involve severance but reconnection.

As a whole, We Animals is a tourney replete with many gauntlets, such as the one thrown down by that decapitated bird. *You are filling me with life*, the bird's eye provokes, *and yet I am dead at your hands. What is it you so wanted me to reveal that you had to do this to me?* In presenting such a speculation, McArthur is not allowing the viewer simply to stand back and be amazed at the sculpted magnificence of the animal's eyes or feathers. Like the studio portraitists, whose detached posers ignore our attendance (although, of course, we're ever present in their framed worlds), McArthur doesn't deny the beauty of the creatures before us. Instead, she wants us to go beyond simply admiring an animal's exquisiteness or placing ourselves in the position of the caged cat or the roped steer, as discomforting as such empathy might be.

It's not enough for my eyes to soften into sentimentality, as it were, or narrow into self-satisfied outrage. I'm not expected to console myself with the bromide that *I* could never do such things. It's not an adequate response to be a passive observer of another being's tragedy or to wave away any distress that might occur with the complacent observation that we're more fiends than angels and that nothing is to be done. It's insufficient to appreciate these creatures and marvel and rage at how

endangered is this various and precious world. And, as in the case of the photograph of the tourists descending on the alligator, McArthur is very aware that our look—even though it might emerge from a removed and "knowing" camera that catches those ludicrous lenses clicking at the "real-life" creature before them—is complicit in cutting up what it sees into what we find valuable and affective and what we decide is worthless and risible. By making herself part of that compromised eye, she's observing how observant (the word hints at an obedient orthodoxy, passivity, and piousness) we become through observation.

The photo of the bird on the desk challenges us because it keeps on bringing us back to the eye. I know there's no life behind the look, just as no body is attached to the head—and yet, try as I might to resist the impulse, I am every moment a Frankenstein, feverishly breathing the *spiritus* into the corpse, within a world of evisceration and decomposition, where my responsibility for the life and death of that creature is total. In the act of quickening lies, I believe, part of the riddle of "the question of the animal"—a question that, for me, is inseparable from the language of revelation, illumination, and, yes, discernment (with its Buddhist overtones of the opening of the third eye and becoming "awake" and, as Mary Margaret Funk shows, the deconstructions of self-delusion found in the work of the Christian Desert Fathers and Mothers).

As I interrogate the subject, I'm aware that by asking the question *of* the animal I must in some way confront the dead-alive creature and ask that question of him or her—with all the foolishness and potential exposure, that combustible mixture of threat and connection, that the inquiry might throw up. Why should we continue to seek more information from a source that may be unreliable? Wouldn't any question simply be a projection onto a mirror that ultimately reflects only ourselves and does not reveal the animal who stares back at us? Why not conclude that the animals' silence, their "cut-offness" and otherness, are reasons enough for us to deduce that we can learn nothing of any value from them, and that our questioning is merely another way of talking to, and about, ourselves?

The obvious response is that, for as much as we may want to dismiss the question of the animal, we keep on coming back to the liminal glass-frame to stare into it. The open-endedness of the interrogative—the question of the question—and the unstill self-reflexivity and projection of our consciousness worry and fascinate us. Our eyebrows rise and our eyes open wider: perhaps in wonderment or credulity, horror or disbelief or realization, or maybe all simultaneously. *Tell us who and why you are*, we address the lens within the face, *so that we may know who and why we are.*

"The question of the animal" not only asks us what we mean when we talk about an *animal* but what or who

we talk about when we refer to *the* animal. Is there something that we could define as *animal*, by which implicitly we draw a distinction between that thing called *animal* and that called *human*? And if we were to ask "the question of the animal" are we not opening ourselves to the possibility that the animal—whatever or whoever that might be—in turn is asking a question of us? And what might that question (or those questions) be? And were we to respond, how would we do so in such a way that the answer would be, at the least, sufficient to the weight of the question?

*　　*　　*

Why the photograph of the polar bear in the zoo? Simply because, like the wedding guest in Samuel Taylor Coleridge's "The Rime of the Ancient Mariner," I was compelled to stop by an insistent presence that had a story to tell, even though more obvious attractions and surer pleasures awaited me elsewhere. Like the mariner with the albatross (another ghostly, dead-alive bird), the photograph evokes an encounter with an animal: one who can't quite be located within the frame of the known or even the imagined; who remains above us, a talisman and guide in our sight, if not beyond the sights and arrows of our desire. The animal in (the) question contains some essence of life and soul (*anima*) that we humans, in our urgent longing for transcendence or

control, or simply on a thoughtless impulse, have sought
to capture in the numerous ways I've outlined already. It's
an animal that in our fevered, guilty imagination is killed
by us and brought back to life, murdered and revivified,
an inspiration and expiration, over and over again.

When Orpheus—he who could enchant the ani-
mals—is led by Hermes into the underworld to rescue
Eurydice, he must always turn around at the threshold
of bringing the dead-alive spirit into the ordinary world.
In every story, the interpretative endeavor—the journey
to rescue meaning from the unconscious and bring it to
the surface—will always fail because we can never trust
our own grasp on truth. *Don't turn and look*, we're told,
and yet we cannot resist. We look and she's alive; as soon
as we look, she's dead. In our turning is the fleeting con-
firmation of the presence; in its confirmation is the irre-
vocable loss.

In Coleridge's poem, the mariner discovers at terrible
cost to himself and his fellow sailors that the lesson that
all our self-justified manhandling teaches is as straight-
forward to proclaim ("He prayeth well, who loveth well/
Both man and bird and beast") as it is seemingly impos-
sible to live by. He also knows that the admonition of
what stems from that loss must be accounted for in a
continual retelling that is both a furthering and an expi-
ation of a curse. If only he could stop his thoughtless self
and not shoot the bird; yet each story repeats the action.
No matter how much we say we won't do it, we kill our

beloved each time. Like the mariner, we must recount, and account for, our actions.

And, to catch a glimpse and glimpse our catch, we're compelled to return to the glass, and breathe on it once again.

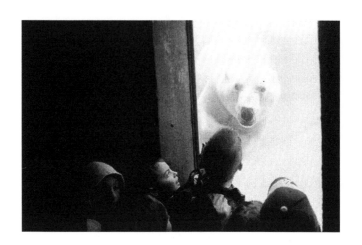

Approach and Encounter

IT'S TIME FOR us to approach the animal. What do we see? Six children cluster around a window that reveals an underwater enclosure. A boy stares at a polar bear, whose massive head and body loom into view on the other side of the glass. Another boy, his back to us, appears to rest his left hand on the pane, as if to reach out and touch the creature that swims toward the group. The bear's black snout seems at the point of kissing the transparent membrane that separates the animal from the children.

The photograph of the polar bear in the zoo is a study in contrasts, enhanced by McArthur's decision to shoot in black and white. The left half of the photograph is shrouded in darkness; the only source of light emanates from the pool on the right-hand side of the picture. A thick plank of wood vertically divides the light from the

dark and literally and metaphorically frames the window through which we see the bear. Although our eyes move freely around the entire space within the external frame of the shot, they are continually drawn back to the light of the pool, the boy's upturned face, the other children's heads, and the bear's coal-colored eyes and snout.

It's axiomatic that a photograph freezes a moment in time. That moment (the German word *Augenblick*, the "glance of the eye," hints at the instantaneity and randomness of the lid closing over the lens) is unavoidably fragmentary at the same time as it evokes the summation of a scene. The fleeting is made static, the contingent is touched with necessity, the impermanent and inconsequential are rendered permanent and significant, and the particular and idiosyncratic are freighted with universality and typicality.

We know nothing of how these children came to be at the zoo that day or what the polar bear was doing before he dove underwater and swam to the window. We aren't aware of what the children said or thought or felt when the bear approached or what they did or talked about immediately afterward. The image provides us with no information about whether the bear regularly appeared at this window or if visitors often came to this spot for precisely such a rendezvous with a powerful, appealing animal. We can't see the enclosure beyond the glass; we've no idea of where the children are heading next. We can't hear their mocking laughter or pay atten-

tion to their murmurings of sadness at the bear's confinement. We can't listen to their gasps of astonishment or notice if the teacher takes them aside and tells them how polar bears are endangered.

What we're left with, then, is what manifests itself before our eyes, which means that we supply our own narrative and interpretative frame to the scene. Even if we were in a position to ask the authorities at the zoo how often the bear came to the window, and what they told us led us to conclude that he seemed to like seeing people in this manner, accruing such data wouldn't close off the *imagined* relationships that the photograph proposes either internally (between this gaggle of children and the solitary animal, the light and dark, and the water of the pool and the air the children breathe) or externally, between the work of art and the viewer. Nor would it preclude *each individual child's* imagined relationship with the animal. We cannot factualize our way out of our projections of what we see. This zoo (which happens to be in Toronto), this animal (whose name happens to have been Kunik), and these children could be anywhere and at any time. What matters is how we *read* the image: what suppositions we bring about animals, children, "nature," and zoos to our inspection.

If we were of a mind to analyze any passing emotion, we might perhaps detect a frisson, a hoped-for echo of our ancestors' putative, originating moments on the tundra or plains, in the woods or streams, within the caves or

beneath the waters, where the mind and body were fully engaged with what was raw and natural and *true*. Enticing, even thrilling, though that last thought might be, it is of course an illusion. We may believe we can recreate our authentic relationship with the nonhuman world by returning to some primal time and a meeting of the animal on its own terms. But, as we've discussed, our emergence from the state of "being animal," as it were, an evolution facilitated by our observation, exploitation, and even consumption of the creatures who surrounded us, means we're always on *the other side* of that knowledge, or moat, or fence, or window.

Perhaps this is why several of the myths of origin that start our sacred scriptures (particularly the Biblical Fall) talk of a great schism or eruption from the natural world: that the emergence into human consciousness and the recognition of the difference between good and evil—the necessary preconditions for moral reflection and, we might say, the essential requirement for the construction of an ethical sensibility—always come at the expense of a loss of innocence, and a realization that, whatever that state of non-knowing was *before*, we no longer have access to it, except through mourning its departure.

That tumble into mor(t)ality is irreparably bound up with the abandonment of our animal brethren; *their* consciousness and world are no longer accessible to us. We struggle to apprehend those distant resonances of what

we imagine was a shared existence with our kin—the kindness that comes from kind-ness. Yet so far off do the reverberations sound that we cannot be sure whether they aren't merely projections of our desire for the broken bond to be resealed. To call forth Hopkins' phrase (in "To Seem a Stranger Lies My Lot, My Life"), we're always at "a lonely began," already in the middle of our journey and isolated from a starting point we never knew. Thus we walk through this world in an *agon* (contestation) that leaves us a part of the Earth and apart from it: neither angel nor animal; neither of the land nor lifted from it; in all elements yet never wholly in one; the friendless, conscious wanderer in a universe seemingly indifferent to our search for meaning.

* * *

But what does it mean to "approach" this window? The word itself amplifies the nostalgic itch we scratch and enflame in that wish to return to a fictional time where we lived in harmony with nature. When we approach something we (literally, from the Latin) move near (*propē*) to it. However close we may come to the object of our fascination, the distance between us is never truly closed. The narrower the gap between us, the more approximate (from *proximē*, closest) our relationship becomes. The more we believe the acquaintance to be exact and the more we see the similarities between us, the more

the differences that illustrate the ultimate inexactness of our relationship are thrown into relief.

Once we get close to someone, we're compelled to respond to the challenges of that propinquity. What is the appropriate or proper behavior to express with that other individual? What would propriety dictate? Appropriateness is built into the very nature of the zoo. We would not, for instance, expect to visit the Toronto Zoo to see cows or pigs lolling about in their pens. It wouldn't be appropriate, because we've decided that those animals whom we consume belong elsewhere: propriety dictates that we not look at the objects of our dinner in the same way in which we observe those whom the majority of us customarily do not rear and kill for food.

As the cognates of *propē* suggest, prevailing social customs intertwine with what we deem a correct, moral affiliation. Which action would be relevant and meaningful, which archaic and/or atavistic? Even if we were to discern what is expected of us, what of the risk that that conduct might turn from an exchange between equals to that of exploiter and exploited? In other words, what might happen should the adjective "appropriate" become the verb, and the propriety of a genuine association based on reciprocity morph into one where one becomes property and the other the proprietor? To echo the language of German theologian Martin Buber, an "I–Thou" connection based on mutual respect and the acknowledged selfhood of the correspondent becomes

an "I–It" correlation, where what was gendered and individual becomes reified and genericized, and one asserts ownership over the other.

The slipperiness of these properties of *propē* indicates that *any* bond always threatens the destruction of its equal exchange—the bond becomes bondage, the intimacy of a connection the clap of the shackles—just as any system of exploitation not only has the potential to reinstate balance but to reverse itself (the exploiter turns into the exploited, and vice versa).

These threats are real: the caregivers who rescue and care for stray animals morph slowly, perhaps unconsciously to themselves, into hoarders, unable to look "properly" after either themselves or the creatures they house. The animals, who are under law considered the property of the pet-*owners*, change in these circumstances into beings who need to be cared for properly: propriety in this case trumps property rights. Or a case such as the young realtor (a man who deals in property) David Villalobos, who wanted "to be one with a tiger" and jumped into an enclosure in the Bronx Zoo to pet the animal and was mauled. Here, the wish to be in proximity with the animal was inappropriate.

In his documentary *Grizzly Man*, Wernor Herzog contends that Timothy Treadwell's messianic, off-kilter passion for the grizzly bears of the Katmai National Park and Preserve in Alaska emerged from "a desire on his part to leave the confines of his humanness and bond

with the bears." Herzog continues: "Treadwell reached out seeking a primordial encounter, but in doing so he crossed an invisible borderline."

There is much to admire in Treadwell's conviction and his deep knowledge of and affection for the wild animals of whom he considered himself the guardian. One can perhaps even see him as a hero willing to lay his convictions on the line—were it not for the fact that one night a bear killed him and his girlfriend, Amy, in an attack so disturbing that Herzog refuses to air an audio recording of the assault in the documentary and urges Treadwell's friend Jewel Palovak never to listen to it. Was this "question of the animal" too awful to be countenanced? And was Timothy Treadwell's terrified "answer" a rejection of his attachment, a confirmation of the ultimate symbiosis between human and bear, the tragic result of the skewed anthropomorphism of a holy fool, or a catastrophic failure of either party to comprehend the terms of their connection? Perhaps—*horribilē et mirabilē dictu*—both were finally in that consummation authentically, reciprocally themselves.

Herzog interviews Sven Haakanson, curator of Alaska's Alutiiq Museum in Kodiac, who notes that although Treadwell may have had the best of intentions, his continued presence with the bears may have not been ultimately in their interests, since it may have habituated them to humans—particularly those who may not have been, as Haakanson puts it, "safe." "For [Treadwell] to

act like a bear the way he did," Haakanson continues in the film, "to me it was the ultimate of disrespecting the bear and what the bear represents. . . . If I look at it from my culture, Timothy Treadwell crossed the boundary we have lived with for 7,000 years. It's an unspoken boundary, an unknown boundary, but when we know we've crossed it, we pay the price." These are the liminal areas of propriety where madness and sanity are determined by an "appropriate" response to the animal. At this frontier all but a few of us instinctively draw back and concede the need for the approximation.

We might symbolize these dis/connections by the hand that one of the children in the photograph looks to have placed on the window, and the bear's paw that might be raised to meet it. Heidegger famously observed that an essential difference between humans and animals was that the latter lacked a hand, even at the most basic level of not having an opposable thumb that makes it possible to clutch (*begriffen*). Echoing Heidegger, what we might call the creature's "pawness" renders it unable to grasp a concept (*begriff*). Let's extend this difference. When we're open-handed the palm holds no weapons or surprises. It may offer up a treat, flatten and distend itself to stroke the fur or receive a lick of the tongue. One palm might meet another and touch in friendship or prayer. At any moment, however, the outstretched hand might close, as one holds fast to an idea. Every thought is potentially rapacious; the open fingers ball themselves

into a fist; we assert control by taking matters into our own hands. We get a grip.

Of course, the bear has claws and a weight that allow it to tear and swat. Nonetheless, we assume such animal violence cannot be malevolent since being unable to grasp or get a handle means by definition that the animal's "unhandedness" is never underhanded. Although we might euthanize creatures that have killed or harmed humans, and in Europe during the Middle Ages domestic animals were put on trial for their "crimes," we find it hard to believe that animals can be manipulative. Their lack of *legerdemain* differentiates the animal's mere appetite from our human greed; it distinguishes a creature's lashing out when under attack from the art and science of warfare; it separates an animal's "honest" wish to claim a territory from our fear of losing control of the world around us.

Nevertheless, for all that we extend the magnanimous right hand of rulership over creation, how freighted with desperation is the human grasp! How quickly our *droit de seigneur* over Nature can become like the Romanian dictator Nicolae Ceauşescu's final, frantic, powerless wave over the unruly masses in December 1989. A tensed and hurried neediness colors the grab, clutch, clench, cling, and snatch: our apprehension that unless we apprehend the property *now*, our greatest desire will be lost and, like Eurydice, will vanish back into the underworld through our beseeching fingers.

Of course, these issues of appropriateness are not only dependent on *our* approach to the window. What if the animal came toward *us*, offered its face to us, or met our gaze? What then?

* * *

Every approach is inherently unstable: an arm extended to hit or caress, an opening up to another, or an encroachment upon someone else's space. What's more, every encounter is a rendezvous, a (re)presentation: for the animal we meet in the zoo has been preceded by our imaginary "animal," the repository of those clustered expectations of what we expect animals to be and do. Because we can never truly *see* an animal for the first time, every approach is tardy, a re-approach—with, on the one hand, the potential for *rapprochement* and, on the other, the possibility of *reproach*. We hope, even expect, the animal will show or do something to prove its animality and be of interest to us—perhaps affirm how like us it is and thereby how much it would like us, unlike the other humans who treat it badly. Perhaps our meeting will heal our primal wound and return us to that authentic space where we knew who we were, who the animal was, and why they and we are on this planet together.

McArthur's photograph dramatically illustrates how the animal comes to meet us as we to meet the animal,

and she inverts our assumptions. The source of light in the image is neither the open air nor a lamp or bulb. Although we presume that the light originates from sunbeams filtered through the water of the pool, within the frames of the window through which we see the creature, the medium is entirely liquid. The intensity of the light is magnified by the brightness of the bear's pelt.

The spaciousness that that light automatically provides means that we almost consciously have to remind ourselves that it is water in which the animal moves and that he's confined in a tank and not swimming in the sea. By contrast, the children—who are, we also need to prompt ourselves, free to move where they wish and to breathe the air that envelops them—are packed into the bottom half of the photograph. The depth of the darkness that surrounds them and their focus on what is on the other side of the glass emphasize the formless and equally sterile medium in which they huddle. The claustrophobia pushes us, like the children, toward the light, where the bear's whiteness and bulk dominate the window. We can make out dimly around the animal the patterned markings of what one assumes is the bottom of the pool, but we have little sense of how large the area is. We note the absence of other aquatic life.

These are not the scene's only peculiarities. No air bubbles escape from the bear's snout or mouth. I would imagine that most of us don't think of polar bears as aquatic, even though they're officially classified as marine

mammals. We may know that polar bears can swim more than six miles per hour and do so without resting for more than fifty-five miles. We may be aware that they can hold their breath underwater for more than a minute. These physical abilities enable them to catch seals and other prey. We may have observed grizzly bears stand on a riverbank or rock or wading into a river or lake to catch fish. Yet we typically see polar bears on land or ice floes, where it is, of course, easier to photograph them. What disorientates us here is that the children are standing *beneath* the surface of the water, looking at the bear that is coming toward them from *above*, as if he were a bird. The perspective turns upside down the "normal" way we observe land or marine mammals—from above or on the level—and visually disturbs the hierarchy of the chain of being that continues to govern our sense of the natural order of things.

The distinctiveness of the bear—the hair lifted and smoothed by the water in which he swims, the sharp points of the eyes and the snout, the small ears—contrasts with the lack of clear detail among the children. On the far left, one child, hooded, isn't regarding the animal at all, but is perhaps gazing at the child standing next to him, who's wearing some kind of hat. All we can make out of the three boys from the right are their heads (one with a cap on) and a backpack. Only the face of the child third from the left is visible, and then only in profile. It could well be *his* hand that touches the pane and not the

hand of the tallest of the children. Those might not be fingers at all. Not all the children might be male.

What do we see when we look into the face of the child whose profile is lit by the pool? His open mouth, wide eyes, and raised eyebrows hint at something like astonishment or even pleasure that this creature is only a few inches away from him. Perhaps the boy, like the bear, is holding his breath. We'd guess that the wonder he feels is because he's so close to so large and powerful an animal; maybe he was taken by surprise as the bear suddenly materialized in front of him. He may even derive part of his delight from the fact that he gets to share this event with his friends.

The only other face we see in full is the bear's. Our assumption is that the creature is staring at the tallest child. But some of the photograph's power derives from the fact that the bear's are the only eyes pointing in *our* direction, and that we ourselves are drawn into this intimate *tête-à-tête*. The rest of the bear's face is inscrutable. The mouth isn't curved in a snarl or a threat; no teeth are bared—however we might choose to "read" such gestures. What's going through the bear's mind, of course, we have no way of knowing.

Yet the face must be faced. As I wrote in chapter one, we are inveterate physiognomists. In fact, Emmanuel Levinas argued that whether a thing could take on a face was fundamental to our sense of that being's selfhood, the demarcation of a meaningful engagement. During

World War II, Levinas was interned in a concentration camp. Each day, a dog that his fellow prisoners called Bobby came to visit them. Levinas was struck that an animal such as Bobby treated him and the other captives as humans, whereas the guards and the Nazi philosophy they espoused considered the prisoners of less worth than animals. However, Levinas himself couldn't countenance the possibility that the dog, who had after all faced him and his fellow human beings and not effaced them as "animals" like their captors, had a countenance akin to the human—with all the "challenge to" and "responsibility for" that comes from recognizing oneself and another self in the Other. For Levinas, although the animal had chosen to come close to the prisoners and enabled him to see *himself* as human, the possibility that the reflected humanity of the animal meant that Levinas might see the human in the animal was a proximity and reflection too far.

As I indicated earlier, the photograph of Kunik in the zoo gives little of its context away. What we *can* learn is that, at the time of this photograph, Kunik, whose name derives from the Inuit term for what in English is called the "Eskimo kiss," was about twenty-five years old. He'd originally been removed from the Northwest Territories as an orphaned cub. A year after this shot was taken, Kunik was bitten by a mosquito, probably on the nose, and fell ill with West Nile Disease, which led to encephalitis and paralysis of the back legs, and finally death.

The disease is unknown in wild polar bears because the mosquito cannot survive so far north—although, given the effects of climate change in the Arctic, Kunik's death might be the harbinger of many more such demises over the next few decades. At the time of his death, Kunik weighed 1200 pounds, and left behind a partner of over twenty years—Bisitek, the zoo's female polar bear—who according to the *Toronto Star*'s report shortly afterward was "thought to be taking the loss in stride," whatever that might mean. (In 2007, Bisitek was moved to the Cochrane Polar Bear Habitat and Heritage Village, 430 miles to the north of Toronto, where she died in 2010.) So, Kunik was not alone in the enclosure, even though he's by himself in this photograph.

These are some of the "facts" of the photo. We like to imagine that some kind of mutuality is being acknowledged—that Kunik wants to see the children as much as some of them do him. But we need to be careful. After all, without the protective glass, any relationship that might be possible between these children and the bear would be compromised by the fact that the latter are large predators around whom it's dangerous for any human being, especially children, to loiter. The boy in profile's wonder and the lack of genuine terror are predicated on the fact that the glass holds firm, the water doesn't pour all over them, and the animal cannot attack. The tremor of satisfaction that such a meeting affords is dependent on it being artificial: the world of water above

that of the air; and children within inches of a predator. Was Kunik "much loved," as the zoo reported, because he wasn't allowed to be the polar bear he wanted to be?

But let's assume that the window into the bear's pool was not placed there solely for our enjoyment, but that the animal *does* take pleasure in looking out of it. Is this window enough to convince us that the animal's life is as good as, if not better than, the life he'd "enjoy" in the natural world? Is it enough to compensate for the lack of space that the enclosure provides for an animal whose range may be thousands of miles in the wild? Does it offset the stereotypical behaviors—swimming or pacing backward and forward, self-mutilation, head nodding up and down, for instance—that characterize the lives of some animals (and humans) who live in barren enclosures with limited stimulation? Is the amount of time the bear spends underwater a "natural" behavior—or is it a learned adaptation that not only alleviates the boredom above ground but is the only way the bear can get close to these other creatures (humans) about whom he's curious and who spend their days staring at him? And, as I've wondered, is that curiosity entirely benign, from either human or animal?

Certainly, those who run zoos and take photographs might hope, in their most altruistic moments, that such meetings will transform these children—make them aware of the beauty and majesty of bears in general, and polar bears in particular. The authorities might voice an aspiration that the sight of this bear in the water could

awaken the next generation to the reality that these mammals are endangered. They might intimate that this bear could alert Canadians to the plight of the native peoples of the north, for whom the bear is a symbol of strength, and, by extension, increase their consciousness of all those endangered species of the North American continent and boreal and polar regions who've been the spirit guides for shamanic trances and native vision quests for millennia—who have, among some peoples, been the reincarnation of human ancestors. Or perhaps they hope that seeing a polar bear up close will simply thrill these children and make them want to come again.

All these are worthy aspirations, and we cannot rule out the possibility that any of them may happen. A more interesting issue, however, is why it should matter to us that the polar bear would want to come to see us and engage with us through the glass. Are we supplying meaning to this brief coming together in some misguided belief that what is being exchanged through the glass is equal? That this "ambassador" is an envoy from another nation presenting his credentials? Is it a salving of our conscience, or more accurately an optical illusion of reciprocity? Or is it an approximation: the nearest one can get without the insanity of an unmediated parley with a predator that would demonstrate just how weak and helpless an animal we are?

The genius of McArthur's photograph is that it conveys the lightness, freedom, and buoyancy of the bear *at*

the same time as it emphasizes how curbed he is within a human-made world—a world reinforced by the fact that his only view beyond the glass is filled with more humans. The darkness and restricted togetherness of the human world from which we stare at Kunik is still a world that's larger than the bear's—although its low-ceilinged gloom exemplifies how limited and dreary we've made it, and how we project our hopes and desires onto the supposedly open and light world of the animals into which we peer in wonder.

So striking is the contrast that we need to remind ourselves each time we look at the photo that we exist beyond the wooden frame that severs the picture in two. We outnumber the animal by at least a factor of six. The bear is reliant on us for his survival, here and in the world at large. He's in the tank, and we're not. We can always walk away. Yet, as the image reminds us, we created the pinched, tightly determined existence we're looking from and at. McArthur's shot opens up the question of just how different life beyond the frames of this photograph really is.

The look on the young boy's face affirms to us our fascination with such talismanic creatures as the polar bear. (McArthur has a similar photo of two little girls in front of the window of a tiger's enclosure. One child is awestruck while another one, bored, stares at her hands.) It satisfies us that these six children can come so close to as strong and "wild" an animal as this polar bear. After all, one of our common beliefs is that children perceive the

nonhuman world more acutely and in a less socially con-
structed manner than adults—that they're as innocent as
the animals they see before them. And so it is here: part
of the photo's power surely lies in what we assume to be
the boy's unaffected and ingenuous astonishment. But is
it as simple as that?

When my brother was a child of six or seven, he had
a group of imaginary friends with whom he'd spend
time in a lean-to next to the garden shed. Some of his
playmates were composed of inanimate matter and some
were invisible to the naked eye, but they all had names
and were of equal importance to him. It was clear to my
parents and me that my brother didn't care whether these
beings were "real." (Indeed, he tells me that he knew
even then that they weren't real beings in the same way,
for instance, as our cats were.) What mattered was that he
could talk freely with them and this provided him with
pleasure, companionship, and encouragement.

My brother appeared to have no difficulty in negoti-
ating the boundaries between worlds, not least because
he *seemed* to make no value judgments regarding the
beings he came into contact with, whether real or imag-
inary. But is this comforting notion true of every child,
including him, or is it in fact an *ex post facto* reading of
our nostalgic wish to return to an Edenic state of con-
nection with the natural and imaginative spheres that
is no longer possible? Perhaps this photograph captures
that wish: a construction that replicates the make-believe

friendships of my brother's lean-to. This way, the polar bear can be both an "ambassador" for the adults and the unthreatening, cuddly, neotenic toy for the kids.

The children we see in this photograph are most probably old enough that their beliefs about what animals are and, indivisibly, what they're *for* have been already formed. If anyone tried to tell these children the ugly reality of surplus breeding programs, hunted mothers and their orphaned cubs, and other reasons why some animals come to be in zoos, they'd most probably be criticized as churlish. *Why disenchant these children when they're so young?* might run the response. *Let them meet the animal first. They'll learn soon enough.*

How do we reconcile the captivation, which is what we imagine to be the expression on the face of the boy in profile, with the fact that this animal is captive? And how do we reflect on our responsibility when both are captured by, and within, the photograph? We believe we know who Kunik is—the loyal and much-loved servant of the Toronto Zoo for a quarter of a century. In his confinement in the zoo, he's neither the suburban black bear who steals from trash cans nor the grizzly who surprises you as you round a corner in Yellowstone Park. He's not Yogi Bear or Winnie-the-Pooh. If Kunik has a role beyond the zoo, he's now a metaphor and chosen totem for our heedlessness and failure to act as Earth's responsible stewards. He's the polar bear standing alone or with a cub on the broken ice floe or lost in an endless

sea in search of food, emblematic of the effects of anthropogenic climate change. What was independence is now isolation; the top predator has become the incarnation of vulnerability.

The polar bear in the zoo thereby becomes a double prisoner: swimming in the tank of the enclosure, the animal can always locate dry land, even though the reason for him to take to the water in the first place (to hunt seals and other marine life) no longer exists, since his food is delivered to him pre-slaughtered, and hunting consists of rummaging for treats his keepers have hidden within the enclosure. That situation might shortly be the case in the wild, when no ice floes exist to swim from or seal pups to be born onto.

* * *

What is it that we want these animals to do for us? Why, after all this time, are we still pulled to watch a polar bear through a glass window swimming toward us, the soft hair almost to hand, the wide neck just asking for our arms to reach around it; our faces lit up, as we huddle together in the darkness and stare into those pupil-less eyes and ask them in some way to connect with our own—in the words of David Villalobos, who leapt into the tiger enclosure, "to be one with" him? And if we should cross the barrier, would this at-one-ment be the form of atonement we expected?

To See and Look Away

MCARTHUR'S PHOTO OF Kunik in the Toronto Zoo calls forth a motif central to many religious traditions: the separation of light and dark. Darkness is associated with ignorance, fear, faithlessness, unreason, the primordial chaos out of which order is created and objects are differentiated, and the matter from which we emerge into the light: at birth, after death, in revelation. Of course, some have racialized darkness and associated skin pigmentation with cursedness and degeneration, but societies of all complexions have honored the sun's rising to banish the night or signal the arrival of spring. Lightness is the realm of knowledge and belief. It celebrates the world above and casts into the shadows the abode of the spirits below. Through the precious ability to *see* into the distance—for safety, percipience, and prophecy—humankind continues its journey forward.

Huddled within the shadows, the children in the photo turn to the area bathed in light and the being encompassed by its glow. Kunik manifests himself, surrounded by an aura: a visitor from an illumined place whom the lost and wayward that crowd the darkness below hope will cast his blessings upon them. That the assembled are children literalizes the metaphor of untutored, easily misled souls who require adjustment in perspective and enlightenment from above.

This *avatar's* suspension in his watery medium renders his weightlessness (the other meaning of "light") otherworldly even as his bulk mightily carries his presence within it. His body seems to merge with, and emerge out of, the liquid—the Latin word for "clear" is *liquidus*—fully formed and wholly focused on us. Interpreted thus, the children's wonder at the polar bear isn't merely amazement at the animal's physicality, but a confirmation through them that we're in the midst of what Hinduism calls a *darshan*—a theophany.

Some of us may anticipate the experience of meeting God as the Ultimate politely tapping on the entrance to our soul, rather in the manner of pre-Raphaelite William Holman Hunt's painting *The Light of the World*. Yet, although Jesus says "knock and the door will be opened unto you" (Matthew 7:7), some theophanies as dramatized in various sacred texts are not comforting, consoling, or forgiving, but shocking and disorientating—so intense that human sensory apparatus isn't equipped to

handle them. In the *Bhagavad Gita*, Krishna warns Arjuna that the full manifestation of his divinity will be too much for the prince's eyes (11:8) and so provides him with supernatural vision. Even then, Krishna's blazing effulgence causes Arjuna's hairs to stand on end (11:14). When Jesus manifests himself to the disciples on Mount Tabor in an episode known as the Transfiguration, his face shines like the sun and his garments are as white as light (Matthew 17:2). Moses and Elijah appear alongside him, before all three are covered in a cloud, which implies that the strength of the light or the sight itself is too great for ordinary mortals.

In John 1:5, the narrator states that the darkness could not overcome the light of the Word (the King James Bible's archaic word for "overcome," *comprehended*, hints that the conflict is between understanding and ignorance and echoes the grasping, prehensile hand in the Latin root of *prendere*, "to take"). In the Hebrew Bible, God speaks to Job out of the whirlwind (Job 38:1) and not at all to Elijah (1 Kings 19:13)—as sensuously extreme a response as the cacophonous wind and earthquake that precede it. Moses turns his face away (Exodus 3:6) on nearing the burning bush, because of his fear of God. When Moses requests to see God's glory, the latter refuses: "You cannot see my face, for no one may see me and live" (NIV Exodus 33:20). Moses must make do with God's "back parts" instead (KJV v. 22).

In the breaking through of the transcendent and

timeless into the mundane and particular, we must look both ways at once: behind us, at everything that's led to that occurrence and yet which now seems wholly irrelevant to the prosecution of the meaning of that epiphany; and forward, convinced of the path we must tread, yet with no idea of how to walk it. The epiphany is ours alone; we are its subject. However, in that we're entirely subject to the demands made within the epiphany, we're not active (the subject). True, some epiphanies occur collectively, such as those that overwhelm the disciples during Pentecost (Acts 2:1–31). However, even here, the transformed individuals speak different languages to the crowds who gather to hear them, and their listeners perceive them to be altered from what, individually and together, they were before.

When Saul of Tarsus is confronted by God on the road to Damascus (Acts 9:3–9) and is asked why he's persecuting him, the incident is so physically and psychically destabilizing that Saul falls from his horse and is blinded for three days. When his sight returns, he's a different person—almost literally, since not only does he adopt another name, Paul, but he switches from zealous persecutor to fearless proselytizer and hunter to hounded. What was obvious to him before is no longer so; what was unimaginable is now the reverse.

As with Moses, Job, and Jonah in the Hebrew Bible, God doesn't initiate Paul into secrets about the past and future of the universe. In fact, Paul doesn't possess spe-

cial skills beyond the energy and tenacity that enable him to prosecute his mission. In spite of Krishna's unveiling, Arjuna is still obligated to go into battle against his relatives. Siddhartha Gautama, whose state of being following his realization of the Four Noble Truths is that he's the Buddha, or the "awakened one," has his eyes opened not to see further but *deeper* into the contingency of all things and the inherent suffering of existence. In other words, illumination hasn't necessarily brought happiness or provided answers; it may, indeed, have only provoked profounder, more challenging questions. What it has opened up, however, is the space for in-*sight* and discernment.

Such hard-headed epiphanies, as it were, come at a cost. One is physical. In his *Conversion on the Way to Damascus* (1601), the Italian artist Michelangelo Caravaggio depicts Paul at the moment he lands flat on his back, gazing sightlessly at his horse, which looms above him. Like McArthur with her polar bear, Caravaggio takes our expectations of the right relationships in religious iconography—where the enthroned sacred figure is placed in the middle of the painting and dispenses grace and justice to those gathered beneath him—and not only tips it on its head by placing the supposedly dominant subject at the base of the painting, but he makes the central figure an animal, which means a realignment of our notion of the "proper" chain of being.

Caravaggio's painting compels our eyes to shuttle between those of the horse and those of the blind

Paul—two faces attempting to establish a connection. The prophet Balaam (Numbers 22:22–33) similarly has to face the consequence of his own inability to see when his donkey observes the angel of the Lord and he, the seer, does not. When the Lord "opens his eyes" and Balaam finally claps eyes on the angel, the terrified prophet falls on his face—a humiliating abasement directly associated with his inability to look ahead, to stand upright, and to sit above or upon the animal. These episodes emphasize how deeply the epiphany sets itself against the human privilege of the face that observes.

Paul calls his new, interior understanding a *scandalon* (1 Corinthians 1:23), Greek for a "stumbling block," from which we get the word "scandal." A stumbling block is an impediment you fall over in the dark or because you can't see clearly. It obstructs you and insists that you pay attention to it in order to move around or over it. It's inherently something you go out of your way to avoid; yet it cannot but trip you up. In fact, for the scandal *to be* a scandal it must be at first unseen to be confronted, at which point it becomes, literally in Paul's case, blindingly obvious.

Paul's conceptualization of the *scandalon*, as he writes in his first letter to the members of the church at Corinth, centers on what, following the resurrection of Jesus Christ, it now means to possess the maturity of insight: "When I was a child, I spoke like a child, I thought like a child, I reasoned like a child; when I became an adult, I

put an end to childish ways. For now we see in a mirror, dimly, but then we will see face to face" (1 Corinthians 13:11–12).

In this passage, Paul is not claiming any greater knowledge, no special vision, following his epiphany. The difference is that he can now discern how *limited* his own vision is, in a way he couldn't before his blindness, when things were self-evident to him. He has become a different person, which has allowed him to identify who he was before in a way he couldn't when he was that person. He needed sightlessness so his exterior senses could be replaced by a vision that's *truer to his interior self* than the one that lies in front of his eyes. It's an essential function of the cross to which he's been exposed and that he now bears, and the paradoxical *chiasmus* that expresses it, that Paul must lose his sight in order to gain insight, and the perspective he gains is to comprehend how poorly he sees. To put it another way, Paul needs the frame of an epiphany to place outside his field of vision the ephemeral and visualizable so that he might concentrate his gaze upon the essential murkiness of the mirror contained within the frames.

The children in front of the glass embody these paradoxes in that, as Paul claims for his own prior state, they come with their limited frames to the glass, naively seeking the clear presence from another world—one wholly other to us, and yet also the familiar, hoped-for, and longed-for explicator of all that remains unanswered.

It's the task of spiritual teachers such as Jesus, the Buddha, Krishna, and others to disabuse our artlessness about what a theophany exacts from us. Like Peter, James, and John in the Transfiguration, we childishly believe we see before us the unveiled and recognizable figure who betokens the *expected* fulfillment of prophecies. We reach out to express our commonality with this spirit—to put up tents in the case of the disciples or to raise a hand to touch the paw in McArthur's photo—only to find that a cloud descends or the glass, for all its polish and apparent transparency, is in fact critically opaque, leaving us with the division of our worlds between the light of the figure above and the enshrouded humans below.

The photograph of Kunik echoes Paul's eschatological hope that we might indeed see face to face the other-than-human and know and be known. The glass and the water are our means to see, yet their membranes diffract and distort the light *and* protect us from the potential annihilation of the epiphany—for it carries a physical, emotional, and spiritual price that we might not be willing to pay. Although he undertakes God's commands, Moses will never see the Promised Land; Jonah will run from God's order, be eaten by a great fish, and yet still not escape his destiny; Job will lose all and never receive a satisfactory answer to *why*? Indeed, one of the ways in which God affirms to Job the essential unanswerability of that *why* is through a series of rhetorical questions (Job 38–41) that remind him of how impotent

and late an arrival he is in comparison with the rest of God's creation.

Given these heavy costs of our exposure to the divine, should the veil be pierced, the frame break, or the glass shatter, and the nonhuman irrupt into our world, what kind of consummation would be attained? Who'd genuinely risk the knowledge of how blind we were before, how utterly in the dark we are, when we realized that what confronted us wasn't a teddy bear but the *tremendum mysterium et fascinans* instead? How might it feel to lose everything, be lower than the beasts, fall victim to the depredations of the flesh that turn us into food as opposed to an obliteration of the self that would raise us to the level of the spirit? Who would be truly ready to face the unprotected face of the Other—whether ursine or divine? It's not surprising that, in the end, we may want the *avatar* to remain in the enclosure for our deflected and refracted entertainment and murky illumination.

The scandal of Christianity is that the Son of God is redemptive not only because of the triumph of the Resurrection over death but also the colossal failure of the Crucifixion: indeed, the return of the light is impossible without the darkness at noon. Jesus is not only the Son of God but, following the typologies laid out in the Hebrew scriptures, he is the Passover lamb of God (Isaiah 53:7); the ram caught in the thicket as Abraham's substitute sacrifice for Isaac (Genesis 22:1–13); *and* the

scapegoat (Leviticus 16:8), cast out into the wilderness to carry away our sins.

By taking on animal forms that are killed, consumed, or rejected and which contain our deepest anxieties about being alienated from the divine through our weaknesses and crimes, Christ as redeemer of the world (if one reads John 3:16 correctly) holds the paradoxes of the light of sinlessness and the dark of corruption *in his own animal body*. In a manner shadowed by McArthur's photograph of the hawk, the bodied Christ-creature refuses to remain a metaphor or symbol—continuously reinserting his abused and abandoned, pierced and bleeding frame into the frame that contains the epiphany: the hawk's head must continuously and simultaneously die and come back to life—killed at our hands and reanimated by our guilt. As our sacrifice, Christ is our animalized substitute so that we, his superiors, might live; but he's also our superior because he was willing to die as an animal sacrifice for us. Christ in his innocence incarnates the unhanded, manhandled creatures that we are too blind to honor appropriately, but *without* whom creation cannot be uplifted. He is forever Bobby.

The scandals don't stop there. We'd never noticed the polar bear before and yet how unavoidable he now is—the scandalous creature and bearer of light who faces (down) our own self-aggrandizement. His appearance before us serves to remind us that our pre-existing vision may have been wholly wrong and that we're now differ-

ent people. Yet such a judgment—an absurd, foolish one for Paul (1 Corinthians 1:23)—threatens to overwhelm us, turn us mad. We'd rather remain blind than acknowledge how lacking in foresight we've been. We'd like to progress from darkness to light in such a way that we didn't have to turn our world upside down. In the end, the scandal would be too much (to) bear.

<div align="center">※ ※ ※</div>

In a now-famous proto-philosophical encounter, Derrida recalled how when his cat saw him naked in the bathroom the unknowability of the feline's stare placed both of them in the interstitial, liminal state—the *en face* that expresses a transpersonal unfamiliarity of total exposure—and, behold, the philosopher was ashamed. As Matthew Calarco writes: "Derrida does not know who this cat is at the moment of the gaze any more than he knows who he is. His encounter with the cat takes place in a contretemps, in a time out of joint, prior to and outside of knowledge and identification. The scene of unknowing in which one finds oneself exposed to the other animal is somewhat akin to madness . . ." (125).

When exposed to the truth—the ancient Greek word for which is *aletheia*, or "un-concealment"—our fearful response is to seek its opposite, which is not lying or dissembling, but hiding, or even more precisely forgetfulness (*lēthē*). By denying animals a genuine chance

to secrete themselves amid the rude rocks and the nata-toria, the zoo claims a kind of truth, an un-concealment, for the creatures it displays to us. The bear in McArthur's photo is always before us, always revealed, always *exposed*. Yet because it cannot hide, it's not the animal we think it is; it remains hidden to and forgetful of itself, in that its animality—its ability to express the full bearness that allows for concealment and attack—isn't honored. Here, too, therefore, we're presented with the paradox of the epiphany. For all that we see the bear through the glass, the more invisible the bear is, precisely because he's unable to hide himself. In that he's also unable to prey on the children, he and we are hidden to his truth.

This observation for me evokes the second cre-ation narrative in Genesis (2:15, 19–20). God provides Adam with the other animals to keep him company in Eden. Adam's task is to tend the garden and to name them—apparently something that the animals cannot do for themselves, as Heidegger believes, and that God wishes Adam to undertake. God's admonition to Adam to "dress" the garden and "keep it," as the King James version evocatively puts it, implies that the natural world is not only incomplete, for it requires human agency to bring forth and retain its beauty, but that it's somehow uncontainable, excessive, unholdable, impudent: without shame.

In giving Adam the "right" to name the animals, God allows him to arrange and define (the Latin word *finis*

means "a border") them, as though the entire planet was, indeed, a park—one necessary even before Noah was ordered to become the first zookeeper and conservationist. God provides comfort to the alienated Adam by literally setting boundaries (Eden is flanked by rivers) that establish what should be of interest to the earthling and what is off-limits. After the Fall, angels with swords guard the garden's gates—frames that connote the lost before (immortality, innocence, nakedness) and the inevitable after (death, sin, and concealment).

This ancient story, which seeks to explicate humankind's differentiation from nature and other animals, also demonstrates how from the outset the human project has been about organizing the world literally *to suit* our purposes—not merely instrumentally as a way of deciding which animals are useful to us and are under our care, and which aren't—but *psychologically*, as a means of "covering up" our own isolation and even insignificance. The phrase "covering up" hints at the falseness and indignity that attend the discovery of our nakedness, and is the opposite of the "uncovering" or "unveiling" that is the literal meaning of *apocalypse*.

Derrida's nakedness is, of course, his natural condition—as it is for all of us. And yet it wasn't his and isn't generally the manner by which we contemporary sophisticates face the world. The cat, on the other hand, is clothed in fur but always naked. McArthur's photo makes the point: When we look at the naked polar bear,

huddled within our hoods and jackets, we search his face not only for some kind of recognition on the animal's part that he sees us, but that we are *revealed*—that we are laid bare, stripped of the illusions and shame that mark our disinheritance from the profligate, raw, and honest purity of Nature. Derrida, like all of us, wants to be known but fears it. For was it not the animal in the form of the serpent who asked the questions that ultimately led to the situation where we became aware of our own state of undress and thus initiated our removal from the blissful unconsciousness in Eden? Was it not the animal who tricked us into moral awareness, who asked us to question our own unknowingness, who clothed us with guilt and made us aware of the trappings of being human? Was this "question of the animal" not in fact the "question of the human"?

The scandal of the serpent's interrogation of the woman is that the former doesn't say anything untrue. Instead, the animal asks the woman to think and make judgments, to evaluate the world in which she finds herself. The animal's insinuation (*sinus* is the Latin for a curve or a fold in a garment) hints at the potential for the upright, linear human to be misled by the indirect approach of the sinewy snake—such as we see with the polar bear coming at us from an angle to the front of the window. The insinuation evokes the pleats and creases that disguise us and allow deception to occur, but also that remove us from Nature's shamelessness and give

us cover. In swathing ourselves in clothing—indeed, in hunting animals so we might hide in their hides—we safely mimic the feral, create our own occlusions, and fall into the falsehood and inauthenticity of concealment.

Ironically, as I noted in the work of the three portrait photographers, the animal's "innocence" is, in fact, a function of our assumption of what it means to be clothed, *seen*, and un(der)handed. For as much as animals wish to hide, they also display themselves and perform by signaling their availability or desire to mate. Many species adopt feints, disguises, camouflage, subterfuge, and other forms of biomimicry (e.g. deceptive calls) to warn off predators or fool their prey in a manner that entices the predator to notice them and not their young. In that regard, therefore, our projection of animals as innocent and naked at our hands is a fantasy conjured by our own superiority to the animal (because we have the ability to make moral choices based on our clothed fallenness) and our envy of the creature (because we cannot help but be sinful and aware of our own nakedness).

As the words *exposé* and *exposure* imply, the photograph does the same, and McArthur's decision to shoot this image in black and white literalizes these paradoxes. Before the arrival of digital photography, one retired to a darkroom to develop the negative: for the black to become white and the white, black; the unseen to be seen. The photograph of the polar bear in the zoo offers up to us the bear's nakedness—his truthfulness—only to

reveal our bad faith, the clothed and concealed forgetfulness within which we've hidden ourselves since the animal's calamitous questioning in the garden. The exposé reveals the scandal; the flashbulb uncovers the flailing human beneath the veneer of the supposedly transparent celebrity.

Is this why we adore and hate these animals so much, why they draw us in and yet cause us to fear what they might present to us? *Avatar* of an overwhelming illumination, the inescapable embodiment of truth, the unavoidable scandal we fear will change us utterly, and the witness to and bearer of our unbearable shame, the bear itself is a glass—the medium through which we're brought into connection with the other-than-human world and the reflector of our anxieties at being plunged into a darkness from which we'll be unable to awake.

⁕　　　⁕　　　⁕

What can we do when confronted with a light and/or face so overwhelming that we risk transfiguration, our eyes at once opened and blinded so that what was invisible becomes visible, light dark, and what we'd ignored, unignorable?

We can shut our eyes and return to the darkness of our normal vision. We can turn away.

In June 1996, I attended the second March on Washington for animal rights in the United States' capital.

Following the march, a few thousand of us gathered in a stadium, which was much too large for the numbers that attended. Amid the inevitable speeches and lectures, a member of People for the Ethical Treatment of Animals (PETA) stepped on stage to announce a new video that his organization had produced. Sitting in the stands amid the cavernous space, I watched what seemed like an endless array of spliced-together clips of domestic and wild animals being abused and slaughtered, set to pulsating rock music. At the end of it, the representative confidently asserted that the sights and sounds we'd been shown and heard would motivate us to end them.

Except that wasn't my reaction at all. Far from being energized by the video, I felt like curling into a ball until the projector was turned off and the noise came to an end. It wasn't that I was particularly squeamish or hadn't seen anything like these scenes on screen before. It wasn't even that I thought it was particularly wrong to show these images: I'm sympathetic to the notion that at some level we owe it to the animals to offer witness to their suffering. What upset me was that the film failed to place these creatures in the context of their own lives. As one after another was beaten or eviscerated in front of my eyes, their individuality began to fade from my consciousness. They became simply another scalded pig or dragged cow or beaten chicken—a response that I imagine matched the thought processes of those carrying out the carnage on the screen. What I'd been presented

with was, in effect, an extended "snuff movie": I may not have been aroused erotically, but I'd shut down important facets of my consciousness (empathy, compassion) in order to cope, in a manner that Melanie Joy defines as "psychic numbing." I was so dismayed—at having been subjected to such horrors and at being made to feel so guilty and helpless—that by the end of the event I wasn't full of righteous and avenging fury but was depleted and exhausted.

I tell this story to introduce another of the many fascinating details in McArthur's photo of Kunik: one of the children, situated at the far left of the group, has lowered his eyelids and turned his face away. It may be that the five other kids have bunched around the window and there's no room for him to see the animal. Indeed, judging by the direction from which the bear is approaching, it might be that the child is unaware of the animal's presence. Perhaps he's momentarily distracted, and what we take for closed eyes is simply that he's glancing at the boy in the hat next to him.

These, of course, are all logical guesses, yet I find this shrouded figure whose gaze is averted a striking, countervailing symbol in a photograph that's all about the act of observation. The angle of the hooded child's head redirects us to the boy next to him and thence to his classmates. *Look at them*, he suggests to the viewer. *Follow the track of their attention*. Nonetheless, even as he asks us to observe anyone else but him, his difference pulls us

back. For all his deference to the focal point, we cannot help but return to his downcast eyes and imagine him saying: *I will not look. I will not see what they see.*

I immediately start to assign reasons, beyond the child's physical location, as to why his face is turned away and why he wears a hood that covers his head and obscures his view. Maybe he isn't impressed by the meet cute between the confined bear and the entertained children. He may want no part of the charade; that this event is nothing more than a desperate desire on our part to feel connected in as hygienic a way as possible with the natural world. To him, it may be neither more nor less genuine than hunting for superannuated and sick animals on a ranch where the would-be trophies have no means of escape; or visiting a safari park where you idle in your car as a lion moseys across the road or baboons steal the windshield wipers; or watching an orca leap through a hoop at SeaWorld. It's no more feral than Mowgli and Baloo the bear, or cuddling one's teddy at night.

Why, the child may ask, do we still believe that wildness is something to be captured in our photographs or for the zoological park? Why do we think when we peer through a glass we're glimpsing Nature in all its unbounded and untrammeled inhuman-ness? Why should, as Tim Flach argues, the civilized and framed world we inhabit be any less authentic than the open range or the tundra?

Unlike his classmates who stare in wonder at the bear

in front of them and who'll nonetheless leave the same as they arrived, the one who turns away may fear an encounter with the animal because he knows he *might* be changed. Perhaps he doesn't want to look because he's frightened by what he'll see; perhaps he's ashamed. He doesn't want to step into the light, be illuminated or revealed; for the light may show him up at the same time as it shows itself to him.

Considering the nature of the epiphanic, it's not surprising that even those of us who think we've been awakened by becoming aware of the systemic exploitation of animals in zoos, farms, laboratories, and circuses may not want to look. It's not because we're indifferent; it's that we're too pained to open our eyes and confront the scandal. Turning away has served us well. Like Paul or the former slaver John Newton, who wrote the poem "Amazing Grace," we may have our particular stories about how we were blind but now we see. We may even forget what we were like before and find ourselves astonished that other people cannot observe what now seems obvious to us—with all of the pained self-righteousness that I discussed earlier on.

But if we were being honest, we'd also recognize that another facet of our being human is that we turn away because the scandal continues in spite of our efforts; that it never goes away because we don't want to risk it all to bring it to an end. We know this because we ourselves once turned away and didn't want to know or take

further responsibility for our blindness. We may have marveled at the animal's size and presence, but we knew that we could walk on and that life would continue in the same way, without any alteration in consciousness or awareness. *In the end*, we may in effect have told ourselves, *it's just a polar bear in the zoo*.

J. M. Coetzee's Elizabeth Costello herself is aware of how compromised and feeble is her own stance on behalf of animals. Her daughter-in-law, whose name Norma encapsulates the comforting anthropocentrism of Cartesian rationality and the standard claims of human uniqueness, wants to maintain the peace of her household while not denying the right of her mother-in-law to visit her grandchildren, and they to see her. And yet Costello's histrionics, her rigid and *unreasonable* refusal to accept a commensality whereby what one eats is only a matter of personal choice and not a moral act, infuriates Norma. Norma considers Costello's choices faddist and "a power-game," manipulating the emotions of her grandchildren so that she, Elizabeth, can feel virtuous and superior.

To the claim made by John Bernard, Costello's son, that her mother-in-law is sincere in her beliefs, Norma replies that the insane are also sincere. As Stephen Mulhall notes: "Costello's immense isolation . . . compel[s] her to resist any invitation or compulsion to articulate her experience in terms of the resources available in a certain, massively familiar way of thinking, the great river

of Reason in Western culture" (73). To Norma, Costello's claim that she speaks out on behalf of animals from a "desire to save my soul" is pretentious and belligerent, and an affront not merely to the tradition that places our concerns in the "rightful" order, but an assault on the correct perspective. Why should Elizabeth's soul need more saving than anyone else's?

The one who turns away is the necessary companion to the one who gawps. As W. H. Auden observes in "Musée des Beaux Arts," a poem that explores the painters of the Dutch tradition in general and *Landscape with the Fall of Icarus* (attributed to Pieter Bruegel the Elder) in particular, suffering occurs unnoticed by people going about their everyday life—the plowman at his furrow, the individual opening a window, the shepherd watching his flock. Even the hopes of older people for the irruption of the theophanic into the mundane are offset by the ordinary pleasures of children who are heedless of, even indifferent to, the miraculous. Why should the young need a reason to be carefree? Even the animals, notes Auden, continue to live their lives apparently unimpressed with, and innocent of, humanity's miseries or its hubris.

No larger message can be learned, Auden continues, from the extraordinary ambition, daring, and imagination shown by Icarus, who on the waxen wings made by his father Daedalus flew too near the sun and drowned. Life—making money, having fun, honoring and relish-

ing the cycle of the seasons—has no reason to valo-
rize the individual grand gesture or the *darshan*. In fact,
since either of these could threaten to destabilize society
because of megalomania (as with Raskolnikov and other
anti-heroes) and/or psychopathy (cf. Timothy Tread-
well), such grandiose gestures may be fine for poets and
artists to reflect on and champion, but to emulate them
would be, to repurpose Norma's complaint and Derrida's
contretemps, the definition of madness.

Seen from this angle, the turning away is, therefore,
not so much fear at what might change, or contempt
at a fake circus act (the performing bear who swims
each day to the window), but a deliberate gesture of
skeptical anti-idealism. It rejects the heroic, individual
gesture for the gentle corralling of our ordinary, col-
lective impulses to seek the common good that comes
about through daily activity—the tilling of the soil,
ice-skating on a pond. It acknowledges that it's wrong to
harm animals, but insists that we'll always utilize them for
our own purposes, and that it's not only unrealistic but
frankly undesirable to expect us to reimagine our entire
economic and social structures as, for instance, vegan-
ism might require. It notes that one measure of social
progress is that we've sublimated our aggression toward
other people by, at least partially, controlling and hurting
animals. We no longer sacrifice humans to propitiate our
gods, we take it out on animals instead; and while one
might wish for humankind to be a little more humane

and kind, our inclinations to favor our own species are, to use words familiar to us from an earlier chapter, proportional and proper.

The child with the averted eyes reminds us yet again of the endlessness of humility. Epiphanies cannot be constructed or coerced; they arrive in front of us and must be stumbled upon as well as over. We may look for all we wish at the polar bear's face, gaze into the olive-shaped eyes, and search for revelation, absolution, sanctification, or whatever it is we want this animal—the representation of the nonhuman world—to provide us with, and see nothing but a reflection of our own desires and insecurities, our boredom and itch for cheap thrills.

Or all of these things, simultaneously. Although we may wish it otherwise, the boy in profile may stare in wonder at the animal and feel nothing but the pleasure of his own wonderment. His classmate may lift his fingers to the window and touch nothing but the coolness of the glass beneath his skin. We may collectively regard this singular animal and revel at its proximity, but in the end the one who looks away reminds us that the stare could simply be self-regard at our own shallow bravery and skill at constructing the artifice of naturalness.

Will we accept this photograph of the bear as a moment out of time that involves an extraordinary transaction between the world of the spirit and that of the flesh? Or are we being judged by the hooded child among the dangerous or gullible who believe they're confronted

with something amazing—a bear falling toward them in the clear light? Auden's reading of Bruegel's *Icarus* and mine of this photograph is that the answer is *both*. The darkness must exist with the light, blindness with illumination, the ordinary with the extraordinary, indifference with complete attention, sacred with profane. These scandals exist side by side—and not in the comforting combination of yin and yang but in a contestation that is obscene, in the sense that Arjuna must kill his cousins and the Son of God on the cross is indistinguishable from the ordinary criminals who flank him. Indeed, as in all these paradoxes, McArthur's compelling vision retains its power precisely *because* of the presence of the one who turns away from the face. We cannot look at the one without seeing the other; as soon as our eye settles on one, it shifts to the other, and back again.

* * *

One reason why I find these components of the photograph of the polar bear in the zoo so resonant is that they display for me the conundrums that have posed themselves throughout my time as an activist. Is the flyer I hand to someone on the street a chance for that person to turn his life around or an annoying piece of paper to be dropped in the nearest trash can? Is the vegan diet a change that opens you up to a whole new world of possibilities or merely (*à la* Norma) a faddish and nitpicky

dietary choice? Is the fact you wonder why you pet your cat and eat the chicken on your plate a moment of illumination or merely one of many unimportant compromises you make between satisfying your taste buds and acting consistently? And why should it be necessary to act consistently when we need a degree of social hypocrisy and dissembling—the covering up that is our human choice—to maintain harmonious social relations?

Are the animals you come across in the zoo creatures who inspire you with wonder and challenge you to reimagine our relationship with the natural world or a way to kill a few hours with the kids? Is this contretemps the one that throws us off our high horse and stuns us into insight or merely a synthetic scene in a tank in a concrete enclosure among other walled and moated pens at the southern end of a province far removed from where polar bears roam free? Is this meeting foreordained and transmogrifying or the rote visitations of two sets of bored animals seeking a momentary relief from the cramped quarters they inhabit?

Like Diego Velásquez's presence in the mirror of his own *Las Meninas* (1656) or Jan Van Eyck's reflection on the wall of his *Arnolfini Portrait* (1434), the child who looks away is effectively McArthur's visual challenge to the viewer on how to observe. Do we open our eyes and stare or do we look away? Is this photograph an exposure of something hidden—a caught moment that captures something essential about our relationship with

the nonhuman—or merely a self-standing work of art, a factitious and manufactured sleight of hand that's something to be glanced at, admired for the skill with which it's composed perhaps, but then turned away from as one moves to the next painting or photograph, the next animal in the next window in the next exhibit? Or, is it, in fact, both: a cause and result of our obsession with *seeing*?

And What If
the Animal Replied?

DERRIDA'S QUESTION, WHICH is the title to
this chapter, echoes the philosopher Ludwig Wittgenstein's
famous and much-discussed *sententia*: "If a lion could talk
we could not understand him." Part throwaway remark,
part thought-experiment, part *koan*, Wittgenstein's obser-
vation can be read in several ways.

One could contend that the statement means that
human language structures are unique to our species and
that any vocalizations the animal might offer wouldn't
be what we consider speech—with its self-referential-
ities, its ability to shape metaphysical questions, jokes,
ambiguities, etc. One could counter the statement and
argue, with Stephen Budiansky, that if a lion could talk,
he wouldn't be a lion: that speech would confer on

the lion a human-ness that would change our attitudes toward what we were hearing—indeed might make us suspicious of the authenticity of the lion's statements *as a lion*. Wittgenstein's aphorism, this argument might run, is thus meaningless, since it renders speech merely another facet of being human, rather than a primary characteristic of our difference. We're not apes that speak; we're persons who come into being through speech.

Another reading would be that the lion's *Umwelt* would be so different from ours—his range of references and conceptualization of the world around him so *un*-human—that even were his language in a grammatical form whereby meaningful sentences were formed (which is questionable given how much language shapes as well as reflects our worldview) we wouldn't be able to understand what he was saying—either in being able to grasp the essence of his experience or, even, what he was referring to.

A further response to Wittgenstein's famous observation is to wonder why it should matter that a lion could talk in the first place. Certainly, as we've already observed, animals have a much wider means of communicating with each other than vocalizations: vibrations for which we've only just developed machines to be able to hear and record, let alone comprehend the meaning of. Apart from the heightened capacities of their sensory organs, various species can "read" atmospheric shifts in ways we cannot: for instance, a cat who can sense a thunderstorm

is coming or the presence of cancer; the creatures that seek the security of higher ground at the approach of a tsunami; the mammals and birds that can locate where all their stores of food are, even though many months may have gone by since they hid them. We may dismiss these abilities as merely instinctual (*merely*, perhaps, because we no longer possess them), but they nonetheless tell us that the world is replete with communicative expressions beyond even the four other senses that we choose to ignore.

For decades now we've been trying to get primates to use sign language or express themselves through paint; we've coaxed animals to observe their reflection in a mirror, or coached parrots to form sentences. We've taught cetaceans, pachyderms, and others to perform tricks that signal their intelligence. All these efforts to prove that animals are smart like *us* beg the question of why we think animals need to be smart *like* us. In all our attempts to ask the "question of the animal" perhaps we've simply been asking them the wrong questions all this time.

Or, more provocatively, perhaps the animals have been responding to our questions for millennia and we've simply lacked the capacities to see, or hear, or smell them? Perhaps the stench of ammonia rising from the crowded chicken sheds on today's factory farms perfectly expresses what the birds are telling us: *Get us out of here.* A tiger's endless wandering back and forth in a zoo's enclosure may not simply be an example of stereotypic

behavior that needs to be ameliorated through toys and tricks, but the animal communicating to us as directly as he can that he feels himself going mad. How do we know that the animals aren't constantly interrogating us—about why we're destroying the planet, about why we hate them so much—and we're simply too blinded by our own self-importance and deaf to any other sounds than our own vain bibble-babble to respond? Perhaps the fossil evidence of the deaths of countless animals and plants is its own kind of silent, accusatory trace, one that for two centuries we've been doing our best to erase by burning their decayed bodies—to such an extent that their charred remains threaten to bring about humanity's downfall.

Each day, as I suggested at the beginning of the book, seems to bring forward another revelation about a world beyond our ken . . . and affirm the magnitude of our failure to grasp its import. In November 2012, for instance, Nathaniel Rich in *The New York Times Magazine* reported on the discovery of a jellyfish that under stressful conditions retains the ability to rejuvenate itself, and, thus, effectively become immortal. Although science has known about this extraordinary phenomenon for over two decades, neither resources, scholars, nor money has been dedicated to understanding it, mainly because, as Rich writes, referencing a professor of marine sciences, "small-bodied organisms are poorly studied relative to larger-bodied organisms." Just as we'd rather stare at

images of charismatic megafauna than "small brown things," as Tim Flach notes, we apparently would much rather fund research on mammals—perhaps, in our plodding and self-regarding way, because we believe that since they look like us they must offer up the greatest secrets.

Our ignorance of the microbiotic is highlighted in Alphonso Lingis's astonishing essay "Bestiality," collected in H. Peter Steeves' volume *Animal Others*. Lingis points out that biological systems traverse all our long-cherished physical borders, which our organizing, framing brain (with its love of boundaries, categories, and taxa) finds hard to comprehend. Far from a self-contained unit that houses the single being that is our self, the human body is a mass of nested ecosystems, replete with organisms both malignant and benign. The surface of our skin is porous and continually changing; our ingestion and egestion of matter are constantly altering our organismic biome. The world outside our body contains as yet uncounted numbers of similarly parasitic and symbiotic relationships and species that don't fit easily into categories of animal, vegetable, or mineral.

The immortal jellyfish affirms that not only does the ocean possess literal and metaphorical depths that have yet to be plumbed, let alone interpreted, but that we lack the conceptual or moral tools with which to process the scientific information that's beginning to present itself to us. For all the other universes that our telescopes and microscopes bring to our vision, we're still the appre-

hensive primate scanning the horizon, judging the world by what we see, and giving names to things. "The world is charged with the grandeur of God," wrote Gerard Manley Hopkins in a poem of the same name. "It will flame out like shining from shook foil." How might we reimagine this metaphor in a planet filled with electromagnetic pulses, infra- and ultrasonic echoes from cetaceans, even bioluminescence?

In the case of the last, contemporary science believes that life forms use bioluminescence for a range of familiar behaviors—such as finding mates and signaling fertility, for warding off predators or tricking prey—as well as to communicate and provide light in the dark places of the world: *fiat lux*. An article on the Scripps Institution of Oceanography's website, linked from the Wikipedia page, states that many creatures carefully calibrate their particular magic. "We know from the study of luminescent organisms that with the exception of bacteria, all organisms have precise control of light emission. To produce light for the wrong reason or at the wrong time" continues the Scripps page, "is a deadly mistake."

Oh that we, the enlightened ones, might be as judicious as these illumined beings and know when darkness is necessary! The Wikipedia page notes that some human uses of engineered bioluminescence include: glowing trees to line highways to save government electricity bills; engineered Christmas trees that don't need strings of bulbs to generate the yuletide spirit; genetically marked

criminals who'd render the prison warder's searchlight moot; and novelty animals. Do we really believe that humankind won't misapply, or hasn't already overused, its partial knowledge to make yet another "deadly mistake"? And is that fatal error to be made for radiant fir trees and effulgent felons?

＊　　＊　　＊

Still another reading of Wittgenstein's statement is to observe that behind the phrase "*could not* understand him" hovers the fear of what the animals might say about us were we to *let* them speak. Like Kafka's chimpanzee Red Peter or Tobermory, the insouciant feline commentator on human follies in Saki's short story of the same name, what that creature knew might require us to refuse to comprehend him should he air the scandal of our treatment of other animals and uncover how much we conceal from each other's faces. Should we be faced with the animal who talks to us, as David Clark notes in his thought-provoking essay on Levinas collected in *Animal Acts*, we'd realize how much we want the animals to be silent, and how much we fear their revelations and insights: "It may well be that as long as animals are quiet, as long as they remain speechless and stupid, they will be allowed into the neighborhood of the human— but always under the threat of deportation—to perform a certain supplemental witnessing work. If the animal

speaks, it will speak only silence, in deference to those who truly possess language and ethics."

The photograph of Kunik, like all images, is silent: an exemplification of how we've privileged sight *and* language and the opposable thumb to determine consciousness. To that extent, "the question of the animal" is merely another self-fulfilling philosophical failure at getting the animal to respond in a manner suited to what we think consciousness is and how it expresses itself—our central belief that the *logos*, the Word, utters being and moral worth into existence.

The twin questions that, since Aristotle, we have asked of animals (*What are animals?* and *What are animals for?*) have insistently borne with them their intimate and unsettling reflections: *What are we?* and *What are we for?* Once we find ourselves confronted with our own image, these questions become less about an appropriate ethical response to the "Other" based on how much they look or act like us. Instead, they evoke a range of answers that speak to our most fragile, desperate selves:

- We are creations of God and our obligation is to worship him.
- We are on an endless cycle of birth, death, and rebirth and our aim should be to release ourselves from that wheel.
- We are mammals and our impulse is to replicate ourselves.

- We are reflections of the universe's consciousness and our goal should be to continue that journey toward higher understanding as part of the universe's continual unfolding.
- We are moral beings and we are meant to be kind.
- We have no idea, and our existence is the extended howl of a dying animal.

These various responses—accompanied by their inherent anxieties, their strategies for silencing heterodoxy or indeterminacy, and their fatalism and metaphysical speculativeness—should give us pause when we return to the questions asked of the animal. Why are we so much more certain that we comprehend the connection between the first question (*What are animals?*) and second question (*What are animals for?*) for nonhuman creatures than we are with those for ourselves? Are we afraid of the toppling of hierarchy that might occur should we fail to answer satisfactorily? Might we in fact turn to these questions of the animal precisely because they allow us to circumvent the questions we dare not face—and in a manner so much less bloodily for humankind than if we were to ask them of ourselves?

The shift in the meaning of "for" between humans and animals only reveals to us how inherently purposive our thinking is toward the world that we consider non-personal. We're much happier projecting ourselves into the gap that exists before the preposition when

it comes to the other-than-human world. In fact, we assume that when we ask the questions of animals, they *await* our assignation. Nature is non-existent until we have explored it; virgin territory is not "wilderness" until we've penetrated it; the creature cannot be said to exist until we've taxonomized and located it within the order of things; a wild animal cannot be admired until we've killed and stuffed it.

Yet, as McArthur's photograph of the polar bear in the zoo attests, it can't be doubted that the animal behind the glass looks at us as much as we look at him. He projects his compelling presence into the space in front of our eyes as much as we project ourselves into the space in front of his. In other words, we are looked at and observed as much as we look and observe: that what we took for merely the act of seeing on the animals' behalf might already have led inexorably toward a judgment—a movement from *What are humans?* to *What are humans for?* that is asked on the other side of the mirror, as it were: a projection from the nonhuman realm that we have as yet no means of knowing, understanding, or evaluating.

And our biggest fear might be that the answer to both is *nothing*.

* * *

I'll continue to advocate, do my best not to eat animals or the products made from their bodies, and press on in

the face of the yet-to-be-envisaged possibility that we might learn the folly of our ways and not let the planet slide into a self-perpetuating carbon- and methane-production spiral that will threaten not just our lives but that of our pet rabbit, even though it may glow in the dark.

It's my fond belief that for all the times we've come to the window in the hope of a cut-price revelation and frustrated that these creatures have not told us what our purpose is, the animals have been telling us for years now that we're on the wrong course—and that we simply haven't been paying enough attention. They've retreated as their habitats have been either fenced in or destroyed. They've mutated and migrated or they've vanished entirely. Even the polar bears now seem to be confirming that the game is up. A report on Yale University's Environment360 website remarks that, because of climate change, grizzlies have been moving north. They've come into contact with polar bears, mated, and have produced hybrid offspring. Perhaps we should see this as good news: that bears in the Arctic and sub-Arctic regions will, like their ecosystem, survive in a manner by merging into one bioregion with one kind of bear. They may not be polar bears as we know them now, but they'll get by. And perhaps that'll be good enough, for us and them.

Zoos may change as well. In 2009, the Toronto Zoo spent $CAN10 million to completely remodel their polar bear exhibit, increasing it to five times the size and

turning it into a ten-acre site called Tundra Trek. On a concrete path that winds among the enclosures, you can, as of 2013, spot the snowy owl, arctic fox, wolf, and reindeer, as well as three polar bears—two eleven-year-old females, Aurora and Nikita, and one seventeen-year-old male, Inukshuk—all of whom lost their mothers to hunters with guns when they were infants and brought to the zoo.

The underground viewing area, from which Jo-Anne McArthur took the photograph of Kunik, now has several windows that open up to the pool. Rafts, balls, and other floating objects provide the bears with "incentivization" packages to keep them from going mad and allow them to while away their days and ours. Earnest videos and panels urge visitors to conserve the northern polar region and not waste energy, in order to mitigate the effects of climate change. Above the window, the new enclosures offer layered rocks, a kind of pebble beach, grottoes, and a large rise that the animals can walk onto.

The expanded space for the Tundra Trek is impressive—a far cry from the hippo's natatorium—although it's strange to have the predatory and prey species in proximity to each other. It's impossible not to believe that the wolves and polar bears cannot see, let alone smell, the reindeer and the arctic fox. How exquisite must be the torture of being so close to death yet incapable of fulfilling one's destiny! What must that do to the senses?

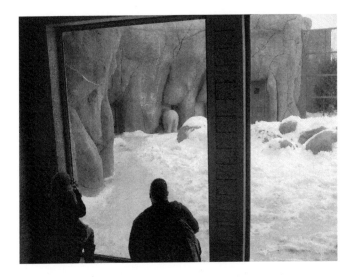

In February 2013, I visited Tundra Trek. The morning was overcast. At zero degrees Celsius and with the snowfall of a week before still thick on the ground, the weather and the landscape were suitably arctic. Because it was 9:30 A.M. on a weekday, we visitors were few in number, but all of the animals had placed themselves on display for us—except for Inukshuk, whom I learned was being kept apart from the two females until after the mating season. Inukshuk's son, Hudson, who judging by the photograph panels scattered around the exhibit had been Tundra Trek's star attraction for the last fifteen months, had a few days earlier been transferred to the Winnipeg Zoo. So a certain valedictory mood hung over the enclosures, especially since Hudson had been

the sole, hand-reared survivor after his mother, Aurora, had rejected her three, prematurely born cubs, and killed two of them.

Aurora and Nikita were being housed in separate pens, and during my visit both females spent a good deal of time pacing up and down along their respective, compacted patches of snow and ice. To my untrained eye, they looked distracted and anxious, not least by the noise of construction that was taking place near the enclosures. They frequently buried their noses in nooks that were on either side of the wall that kept them apart, sniffing around the solid gates that separated the pens from each other. According to the blogger "Dave," writing on the website Knutisweekly.com, the zoo was keeping the bears away from each other because, the staff theorized, Aurora as the dominant female may have been suppressing Nikita's reproductive hormones, and it was hoped that the isolation might change this imbalance and both bears would be able to have offspring again. It's probably too facile a speculation that Aurora's lifelong confinement in the zoo and the loss that has weighed upon this exhibit was presaged by the pathology of death that marked Aurora as an orphaned child and led to her murdering two of her own. Sometimes animals do not nurture their young, even in the wild and when food sources are available.

Whatever psychic confusion may exist in the minds of the polar bears, it's impossible to ignore the presence

of our schizophrenic self at the heart of this exhibit. We're urged to learn more about the bears and do all we can to conserve them in the wild, and yet the creatures that wandered back and forth that day in front of me were there because we killed their mothers. We're horrified that a mother would murder her own children (*How cruel and unfathomable are the ways of nature!*), and yet we stifle or manipulate the instincts of these and other animals in countless ways in order to gain our satisfactions—whether from eating their flesh, petting them, watching them with awe, and having them conveniently located—and we try to get them to breed again.

We demand that animals present themselves before us, for the cubs to play and frolic for the amusement of our own children. Yet we want them to remain mysterious and exotic to us, for without the fear and unknowability that extend from their wildness, they're potentially merely domestic, contemptible bores. In this exhibit, large glass screens enclose the entire area and provide uninterrupted viewing of the animals, and they of us. But we need a screen not simply to guard us from an animal's attack, but to protect the bears from any food or objects that we might throw in. Including, one assumes, ourselves.

As I observed Nikita lope toward the large window through which I looked at her, raise her snout in my direction, dip her body to the right, and pad to the back of the pen to wheel again toward me, I was enveloped

by the overwhelming sadness of the frames in which we found ourselves: two mammals going through the motions, seeking out a more authentic connection with one another, and lifting our heads into the air in anticipation of something intangible and ill-defined manifesting itself before us—something ... *anything* ... to distract us from the compacted, worn grooves that defined our world and our limited view of it.

I filmed her for a while, took a few photos, and even mumbled a word or two—half in sympathy, half in encouragement. But I was cold, I had a plane to catch, and I'd got what I'd come for. So, exercising my prerogative, I switched the camera off, turned, and walked away. And I didn't look back.

Discussion Questions

1. The notion of the frame is used as a construction for the author's interpretations. How might you employ the frame in your particular interest or academic discipline? What are the opportunities provided by, and limitations of, the frame analogy?

2. How is your experience of activism for your chosen passion different from or similar to the author's? What lessons might you draw from these differences and similarities to move your cause forward?

3. The book presents a variety of criticisms about animal activism and veganism. Do any of them resonate with you particularly, and why? How would you go about responding to them?

4. *The Polar Bear in the Zoo* concentrates on the animal in the zoo and in still photography. How might the experience of viewing the animal be different in movies or on safari?

5. The book draws on motifs found in sacred scrip-

tures, but doesn't explicitly endorse a religious perspective. It also evokes a conversion narrative as a way of describing animal activism. Do you consider such religious motifs limiting or liberating? How would you construct the narrative of your own motivations to bring about change?

6. The author claims that he's adopted an existential advocacy. How do you maintain confidence that your own cause will one day be satisfied? What reasons can you come up with that support your belief and what might undermine that confidence?

7. *The Polar Bear in the Zoo* maintains that the one who looks away is always alongside the one who looks. Do you agree? Can you think of examples where you are someone who looks away, and, if so, why?

8. It's suggested that the one who looks away represents a moderate voice, willing to tolerate animal exploitation at the risk of something potentially socially destabilizing. Where do you find yourself on this continuum? Do any of your views surprise you, or others? What might you be open to re-examining, and what worries or excites you about the consequences of that re-examination, should it occur?

9. The author provides a number of responses to how one might answer, "What are humans for?" Can you think of others? What might be the approaches

to animals offered by your answer to "What are humans for?"

10. Do you have a favorite photograph or work of art that has forced you to examine your life? If so, how did it do this?

Bibliography

The following is a select bibliography of some of the books and articles I've read over two decades as an animal activist, editor, and publisher, and which have influenced my thinking and worldview accordingly. The asterisked (*) titles are cited in *The Polar Bear in the Zoo*.

Animal Advocacy

Baur, Gene. *Farm Sanctuary: Changing Hearts and Minds About Animals and Food*. New York: Touchstone, 2008.

Bekoff, Marc, and Carron A. Meaney, eds. *Encyclopedia of Animal Rights and Animal Welfare*. Westport, Conn.: Greenwood Press, 1998.

Bekoff, Marc, and Dale Jamieson, eds. *Readings in Animal Cognition*. Cambridge, Mass.: MIT Press, 1996.

Best, Steven, and Anthony Nocella II, eds. *Terrorists or Freedom Fighters? Reflections on the Liberation of Animals*. New York: Lantern Books, 2004.

Carman, Judy. *Peace to All Beings: Veggie Soup for the Chicken's Soul*. New York: Lantern Books, 2003.

Cooney, Nick. *Change of Heart: What Psychology Can Teach Us About Spreading Social Change.* New York: Lantern Books, 2011.

Francione, Gary. *Rain without Thunder: The Ideology of the Animal Rights Movement.* Philadelphia: Temple University Press, 1996.

Hargrove, Eugene C., ed. *The Animal Rights/Environmental Ethics Debate: The Environmental Perspective.* Albany: SUNY Press, 1992.

Hawthorne, Mark. *Striking at the Roots: A Practical Guide to Animal Activism.* Ropley, U.K.: O Books, 2008.

Jasper, James M. and Dorothy Nelkin. *The Animal Rights Crusade: The Growth of a Moral Protest.* New York: The Free Press, 1992.

LaFollette, Hugh, and Niall Shanks. *Brute Science: Dilemmas of Animal Experimentation.* London: Routledge, 1996.

Lovitz, Dara. *Muzzling a Movement: The Effects of Anti-Terrorism Law, Money, and Politics on Animal Activism.* New York: Lantern Books, 2010.*

Munro, Lyle. *Confronting Cruelty: Moral Orthodoxy and the Challenge of the Animal Rights Movement.* Leiden: Brill, 2005.

Phelps, Norm. *The Longest Struggle: Animal Advocacy from Pythagoras to PETA.* New York: Lantern Books, 2007.

Rice, Pamela. *101 Reasons Why I'm a Vegetarian.* New York: Lantern Books, 2005.

Rowe, Martin, ed. *The Way of Compassion: Vegetarianism, Environmentalism, Animal Advocacy and Social Justice.* New York: Stealth Technologies, 1999.

Silverstein, Helena. *Unleashing Rights: Law, Meaning, and the Animal Rights Movement.* Ann Arbor: University of Michigan Press, 1996.

Singer, Peter. *Ethics into Action: Henry Spira and the Animal Rights Movement.* Lanham, Md.: Rowman & Littlefield, 1998.

Animals

Balcombe, Jonathan. *Second Nature: The Inner Lives of Animals.* New York: Palgrave Macmillan, 2010.

Herzog, Werner, dir. *The Cave of Forgotten Dreams.* Creative Differences, 2010.

——. *Grizzly Man.* Lions Gate Films, 2005.*

Manes, Christopher. *Other Creations: Rediscovering the Spirituality of Animals.* New York: Doubleday, 1997.

Masson, Jeffrey Moussaieff, and Susan McCarthy. *When Elephants Weep: The Emotional Lives of Animals.* New York: Delacorte Press, 1995.

Page, George. *Inside the Animal Mind: A Groundbreaking Exploration of Animal Intelligence.* New York: Broadway Books, 1999.

Rich, Nathaniel. "Can a Jellyfish Unlock the Secret of Immortality?" *New York Times,* November 28, 2012.*

Siebert, Charles. *The Wauchala Woods Accord: Toward a New Understanding of Animals.* New York: Scribner, 2009.

Wikipedia. "Bioluminescence." Citing the article, "Bioluminescence Questions and Answers," <http://siobiolum.ucsd.edu/Biolum_q&a.html> (accessed November 28, 2012).*

Polar Bears

Animal People. Obituaries. November 2006 <www.animalpeoplenews.org/06/11/animalobits1106.html> (accessed August 29, 2012).*

CBC News. "Mosquito Fells 545-kg Polar Bear at Toronto Zoo," October 25, 2006 <www.cbc.ca/news/canada/story/2006/10/25/bear-westnile.html> (accessed August 8, 2012).*

Chartrand, Leon. "Bears." Macmillan Encyclopedia of Religion, ed.-in-chief, Lindsay Jones. Farmington Hills, Mich.: Thomson Gale, 2005, pp. 806–810.*

Dave. "Have a Happy Life in Winnipeg, Dear Hudson," Knutisweekly.com <http://knutisweekly.com/2013/02/have-a-happy-life-in-winnipeg-dear-hudson> (accessed February 19, 2013).*

Environment360. "Unusual Number of Grizzly and Hybrid Bears Spotted in High Arctic," <http://e360.yale.edu/digest/unusual_number_of_grizzly_and__hybrid_bears_spotted_in_high_arctic/3567/> (accessed November 28, 2012).*

Hall, Joseph. "West Nile Virus May Have Killed Zoo's Polar Bear," *Toronto Star*, October 25, 2006.*

Hopper, Tristan. "Two Cubs Die as Mother Polar Bear Turns on Her Three Newborns," *National Post*, October 12, 2011.*

Robson, Dan. "Returning Polar Bear Orphans Get Fancier Digs," *Toronto Star*, July 4, 2009.*

Factory Farming and Veganism

Brighter Green. Climate Change and the Globalization of Factory Farming: Brazil, China, Ethiopia, and India <http://brightergreen.org/brightergreen.php?id=24> (accessed October 23, 2012).*

Davis, Karen. *Prisoned Chickens, Poisoned Eggs: An Inside Look*

at the Modern Poultry Industry. Summertown, Tenn.: Book Publishing Company, 1996.

Eisnitz, Gail A. Slaughterhouse: *The Shocking Story of Greed, Neglect, and Inhumane Treatment Inside the U.S. Meat Industry*. Amherst, N.Y.: Prometheus Books, 1997.

Food and Agriculture Organization of the United Nations. *Livestock's Long Shadow: Environmental Issues and Options*. Rome: UNFAO, 2006 <ftp://ftp.fao.org/docrep/fao/010/a0701e/a0701e.pdf> (accessed December 4, 2012).

Fiction and Poetry

Auden, W. H. *Selected Poems* (edited by Edward Mendelson). London: Faber and Faber, 1979.*

Coleridge, Samuel Taylor. "The Rime of the Ancient Mariner" in *Coleridge: Poems* (edited by John Beer). London: J. M. Dent & Sons, 1974, pp. 173–189.*

Conrad, Joseph. *The Secret Agent*. Harmondsworth, Middx.: Penguin Books, 1980.*

Coetzee, J. M. *Disgrace*. London: Vintage, 2000.*

——. *Elizabeth Costello*. London: Secker & Warburg, 2003.

——. *The Lives of Animals*. Princeton: Princeton University Press, 1999.*

——. *Slow Man*. New York: Viking Penguin, 2005.

Dostoevsky, Feodor. *Crime and Punishment* (translated by David Magarshack). Harmondsworth, Middx.: Penguin Classics, 1966.*

Eiseley, Loren. "The Star Thrower from the Unexpected Universe," <www.eiseley.org/Star_Thrower_Cook.pdf> (accessed December 4, 2012).*

Eliot, T. S. *The Complete Poems and Plays of T. S. Eliot*. London:
 Faber and Faber, 1969.*

Hopkins, Gerard Manley. *The Poems of Gerard Manley Hopkins*
 (edited by W. H. Gardner and N. H. MacKenzie). Oxford:
 Oxford University Press, 1982.*

Jennings, Elizabeth. "Letter from Assisi," in *Selected Poems*.
 Manchester: Carcanet, 1979.*

Kafka, Franz. "A Report for an Academy," <http://records.
 viu.ca/~johnstoi/kafka/reportforacademy.htm> (accessed
 December 9, 2012). The short story is discussed in Coet-
 zee, *The Lives of Animals* (q.v.).*

Saki. "Tobermory," <www.sff.net/people/doylemacdonald/l_
 tober.htm> (accessed December 9, 2012).*

Philosophy and Social Thought

Adams. Carol J. *Neither Man nor Beast: Feminism and the Defense
 of Animals*. New York: Continuum, 1995.

———. *The Pornography of Meat*. New York: Continuum, 2003.

———. *The Sexual Politics of Meat: A Feminist-Vegetarian Critical
 Theory*. New York: Continuum, 1990.

Berger, John. "Why Look at Animals?" from *About Looking*.
 New York: Vintage International, 1980.*

Budiansky, Stephen. *If a Lion Could Talk: Animal Intelligence and the
 Evolution of Consciousness*. New York: The Free Press, 1998.*

Bulliet, Richard W. *Hunters, Herders, and Hamburgers: The Past
 and Future of Human–Animal Relationships*. New York:
 Columbia University Press, 2005.

Calarco, Matthew. *Zoographies: The Question of the Animal from
 Heidegger to Derrida*. New York: Columbia University Press,
 2008.*

Cavalieri, Paola. *The Death of the Animal: A Dialogue* (with Matthew Calarco, John M. Coetzee, Harlan B. Miller, Cary Wolfe). New York: Columbia University Press, 2009.*

Clark, David. "On Being 'The Last Kantian in Nazi Germany,'" in Ham and Senior (q.v.).*

Clark, Stephen R. L. *Animals and Their Moral Standing.* London: Routledge, 1997.

Cohen, Carl, and Tom Regan. *The Animal Rights Debate.* Lanham, Md.: Rowman & Littlefield, 2001.

DeMello, Margo, ed. *Human–Animal Studies: A Bibliography.* New York: Lantern Books, 2012.

——. *Teaching the Animal: Human–Animal Studies across the Disciplines.* New York: Lantern Books, 2010.*

Derrida, Jacques. *The Animal That Therefore I Am* (edited by Marie-Louise Mallet). New York: Fordham University Press, 2008.*

Dombrowksi, Daniel A. *Babies and Beasts: The Argument from Marginal Cases.* Urbana: University of Illinois Press, 1997.

Donovan, Josephine, and Carol J. Adams, eds. *Beyond Animal Rights: A Feminist Caring Ethic for the Treatment of Animals.* New York: Continuum, 1996.

Fellenz, Marc R. *The Moral Menagerie: Philosophy and Animal Rights.* Urbana and Chicago: University of Illinois Press, 2007.*

Gray, John. *Straw Dogs: Thoughts on Humans and Other Animals.* London: Granta, 2002.*

Ham, Jennifer, and Matthew Senior, eds. *Animal Acts: Configuring the Human in Western History.* New York: Routledge, 1997.*

Harpignies, J. P. *Political Ecosystems*. New York: Spuyten Duyvil, 2004.

Joy, Melanie. *Why We Love Dogs, Eat Pigs, and Wear Cows: An Introduction to Carnism*. San Francisco: Red Wheel Weiser, 2010.*

Kierkegaard, Søren. *Fear and Trembling* (trans. Alastair Hannay). London: Penguin Classics, 1985.*

Lacapra, Dominick. *History and Its Limits: Human, Animal, Violence*. Ithaca, N.Y.: Cornell University Press, 2009, ch. 7, "Reopening the Question of the Human and the Animal," pp. 149–189.

Lawlor, Leonard. *This Is Not Sufficient: An Essay in Animality and Human Nature in Derrida*. New York: Columbia University Press, 2008.*

Mason, Jim. *An Unnatural Order: The Roots of Our Destruction of Nature*. New York: Lantern Books, 2005.*

Midgley, Mary. *Beast and Man: The Roots of Human Nature*. London: Routledge, 1995.

Mulhall, Stephen. *The Wounded Animal: J. M. Coetzee & the Difficulty of Reality in Literature & Philosophy*. Princeton: Princeton University Press, 2009.*

Nagel, Thomas. "The Taste for Being Moral." *The New York Review of Books*, December 6, 2012.*

——. "What Is It Like to Be a Bat?" *The Philosophical Review*, Vol. 83, No. 4 (October, 1974), pp. 435–450.*

Pluhar, Evelyn B. *The Moral Significance of Human and Nonhuman Animals*. Durham, N.C.: Duke University Press, 1995.

Regan, Tom. *The Case for Animal Rights*. Berkeley: University of California Press, 1983.

——. *Empty Cages: Facing the Challenge of Animal Rights*. Lanham, Md.: Rowman & Littlefield, 2004.

———. *The Thee Generation: Reflections on the Coming Revolution*. Philadelphia: Temple University Press, 1991.

Rowlands, Mark. *Animal Rights: A Philosophical Defence*. New York: St. Martin's Press, 1998.

Sapontzis, S. F. *Morals, Reason, and Animals*. Philadelphia: Temple University Press, 1987.

Scully, Matthew. *Dominion: The Power of Man, the Suffering of Animals, and the Call to Mercy*. New York: St. Martin's Griffin, 2002.

Shepard, Paul. *The Others: How Animals Made Us Human*. Island Press: Washington, D.C.: 1997.

Simons, John. *Animal Rights and the Politics of Literary Representation*. Basingstoke, U.K.: Palgrave, 2002.*

Singer, Peter. *Animal Liberation*. New York: Ecco Books, 2002.

Singer, Peter, ed. *In Defense of Animals*. New York: Harper Perennial, 1985.

Sorabji, Richard. *Animal Minds & Human Morals: The Origins of the Western Debate*. Ithaca, N.Y.: Cornell University Press, 1993.

Steeves, H. Peter, ed. *Animal Others: On Ethics, Ontology, and Animal Life*. Albany: SUNY Press, 1999.*

Tuttle, Will. *The World Peace Diet: Eating for Spiritual Health and Social Change*. New York: Lantern Books, 2005.

Wolfe, Cary, ed. *Philosophy & Animal Life* (Essays by Stanley Cavell, Cora Diamond, John McDowell, Ian Hacking, and Cary Wolfe). New York: Columbia University Press, 2008.*

———. *Zoontologies: The Question of the Animal*. Minneapolis: University of Minnesota Press, 2003.*

Yoerg, Sonja I. *Clever as a Fox: Animal Intelligence and What It Can Teach Us about Ourselves*. New York: Bloomsbury, 2001.

Photography

Balog, James. *Endangered Wildlife* <www.jamesbalog.com/portfolios/endangered-wildlife/> (accessed August 28, 2012). See also his *Survivors: A New Vision of Endangered Wildlife*. New York: Abrams, 1990.*

Barthes, Roland. *Camera Lucida: Reflections on Photography*. New York: Farrar, Straus and Giroux, 1981.

Greff, Barry Steven. *Of the Wild* <http://barrystevengreff.com> (accessed August 27, 2012).*

Flach, Tim. *Body Language*. His photographs are featured in *More Intelligent Life*, a supplement of *The Economist* magazine <http://moreintelligentlife.com/gallery/body-language> (accessed August 27, 2012), in his book *More than Human* (New York: Abrams, 2012), and in the portfolio of the same name at www.timflach.com (accessed August 27, 2012.)*

Jensen, Derrick, and Karen Tweedy-Holmes. *Thought to Exist in the Wild: Awakening from the Nightmare of Zoos*. Santa Cruz, Ariz.: No Voice Unheard, 2007.*

McArthur, Jo-Anne. *We Animals* <www.weanimals.org> (accessed December 4, 2012). Jo-Anne is featured in the documentary film *The Ghosts in Our Machine*, directed by Liz Marshall, 2013 <www.theghostsinourmachine.com/> (accessed December 4, 2012).*

Noelker, Frank. *Captive Beauty*. Urbana and Chicago: University of Illinois Press, 2004.*

Reed, Susan. "Photographer James Balog Captures the Plight of Endangered Species with a Stark and Startling Eye," *People*, December 10, 1990.*

Sontag, Susan. *On Photography*. New York: Picador, 1977.

Religion

Buber, Martin. *I and Thou*. New York: Charles Scribner's Sons, 1970.*

Carse, James. *Breakfast at the Victory: The Mysticism of Ordinary Experience*. San Francisco: HarperSanFrancisco, 1994.

Chapple, Christopher Key. *Nonviolence to Animals, Earth, and Self in Asian Traditions*. Albany: SUNY Press, 1993.

Foltz, Richard C. *Animals in the Islamic Tradition and Muslim Cultures*. Oxford: Oneworld Publications, 2006.

Fox, Michael A. *The Boundless Circle: Caring for Creatures and Creation*. Wheaton, Ill.: Quest Books, 1996.

Funk, Mary Margaret. *Discernment Matters: Listening with the Ear of the Heart*. Collegeville, Minn.: Liturgical Press, 2013.*

Gottlieb, Roger S., ed. *This Sacred Earth: Religion, Nature, Environment*. New York: Routledge, 1996.

Hyland, J. R. *God's Covenant with Animals: A Biblical Basis for the Humane Treatment of All Creatures*. New York: Lantern Books, 2000.

Kowalski, Gary. *The Bible According to Noah: Theology as if Animals Mattered*. New York: Lantern Books, 2001.

Linzey, Andrew. *Animal Theology*. Urbana: University of Illinois Press, 1995.

———. *Christianity and the Rights of Animals*. Crossroad: New York, 1991.

———. *Creatures of the Same God: Explorations in Animal Theology*. New York: Lantern Books, 2009.

Linzey, Andrew, and Dan Cohn-Sherbok. *After Noah: Animals and the Liberation of Theology*. London: Mowbray, 1997.*

Linzey, Andrew, and Dorothy Yamamoto, eds. *Animals on the*

 Agenda: Questions about Animals for Theology and Ethics. Urbana: University of Illinois Press, 1998.

McDaniel, Jay B. *With Roots and Wings: Christianity in an Age of Ecology and Dialogue*. Maryknoll, N.Y.: Orbis Books, 1995.

Phelps, Norm. *The Dominion of Love: Animal Rights According to the Bible*. New York: Lantern Books, 2002.

——. *The Great Compassion: Buddhism & Animal Rights*. New York: Lantern Books, 2004.

Pinches, Charles, and Jay B. McDaniel, eds. *Good News for Animals? Christian Approaches to Animal Well-Being*. Maryknoll, N.Y.: Orbis Books, 1993.

Radhakrishnan, Sarvepalli, and Charles A. Moore, eds. *A Sourcebook in Indian Philosophy*. Princeton: Princeton University Press, 1957.*

Rosen, Steven. *Diet for Transcendence: Vegetarianism and the World Religions*. Badger, Calif.: Torchlight Publishing Inc., 1997.

Webb, Stephen H. *On God and Dogs: A Christian Theology of Compassion for Animals*. Oxford: Oxford University Press, 1998.

Young, Richard Alan. *Is God a Vegetarian? Christianity, Vegetarianism, and Animal Rights*. Chicago: Open Court, 1996.

Zoos

Norton, Bryan G., Michael Hutchins, Elizabeth F. Stevens, and Terry L. Maple, eds. *Ethics on the Ark: Zoos, Animal Welfare, and Wildlife Conservation*. Washington, D.C.: Smithsonian Institution, 1995.*

Politi, Daniel. "Man Who Was Mauled in Bronx Zoo 'Wanted To Be One With the Tiger.'" Slate.com, September 22, 2012.*

About the Author

 MARTIN ROWE is the author of *The Polar Bear in the Zoo*, *The Elephants in the Room*, and *The Bugs in the Compost* (all published by Lantern Books). He is the editor of *The Way of Compassion* (Stealth Technologies, 1999) and the founding editor of *Satya: A Magazine of Vegetarianism, Environmentalism, Animal Advocacy, and Social Justice*. He is also the author of *Nicaea: A Book of Correspondences* (Lindisfarne, 2003), co-author of *Right Off the Bat: Baseball, Cricket, Literature & Life* (Paul Dry Books, 2011), and the co-founder of Lantern Books. He lives in Brooklyn, New York.

About the Publisher

LANTERN BOOKS was founded in 1999 on the principle of living with a greater depth and commitment to the preservation of the natural world. In addition to publishing books on animal advocacy, vegetarianism, religion, and environmentalism, Lantern is dedicated to printing books in the U.S. on recycled paper and saving resources in day-to-day operations. Lantern is honored to be a recipient of the highest standard in environmentally responsible publishing from the Green Press Initiative.

www.lanternbooks.com